THE INNOVATIVE ARTIST

ABSTRACTS & MIXED MEDIA

Dedication
In loving memory of my late husband Nick; and to my sister Liz and 'oldest' friend Di for their support, encouragement and laughter.

First published in 2022
Search Press Limited
Wellwood, North Farm Road,
Tunbridge Wells, Kent TN2 3DR

Text copyright © Helen Kaminsky, 2022.
Photographs by Mark Davison for Search Press Studios, 2022, except for pages 28 and 30 (reference photographs) by Antoniela Ginourie, and cover flaps (topmost images), pages 6 (top right), 52 (top band and bottom) and 53 (top band and top right) by Claire Du Plessis. All other photographs supplied by the author.
Photographs and design copyright © Search Press Ltd. 2022.

All rights reserved. No part of this book, text, photographs or illustrations may be reproduced or transmitted in any form or by any means by print, photoprint, microfilm, microfiche, photocopier, video, internet or in any way known or as yet unknown, or stored in a retrieval system, without written permission obtained beforehand from Search Press. Printed in China.

ISBN: 978-1-78221-877-7
ebook ISBN: 978-1-78126-846-9

The Publishers and author can accept no responsibility for any consequences arising from the information, advice or instructions given in this publication.

No use of the artwork for commercial purposes is permitted without the prior permission of both artist and Publishers. Readers are permitted to reproduce or copy the paintings in this book only for private and personal study/practice.

Suppliers
If you have difficulty in obtaining any of the materials and equipment mentioned in this book, please visit the Search Press website for details of suppliers: www.searchpress.com

You are invited to visit the author's website at: www.helenmkaminsky.com

Publishers' note
All the step-by-step photographs in this book feature the author, Helen Kaminsky, demonstrating how to paint abstracts and work with mixed media. No models have been used.

THE INNOVATIVE ARTIST

ABSTRACTS & MIXED MEDIA

Brilliant new ways with colour, texture and form

Helen Kaminsky

Search Press

CONTENTS

INTRODUCTION	6
INSPIRATION	10
Demonstration: The Toolmaker	*12*

The art of the abstract — 18

COLOUR	20
Demonstration: Rock Strata	*28*
Demonstration: The Meeting of the Waters	*30*
COMPOSITION	36
Demonstration: Playtime with Matisse	*40*
DESIGN	42
Demonstration: Rocky Road	*42*
INTERPRETATION	46
Demonstration: Pollen for the Bees	*46*
MY WORKING PROCESS	52
Demonstration: Cottage on a Hillside	*57*

Materials and tools — 60

Mixing the media — 72

CREATING BACKGROUNDS	74
Demonstration: New Directions	*80*
Demonstration: An Artist's Garden	*87*
Demonstration: A Different Perspective	*95*
COLLAGE	100
Demonstration: Retro City	*114*
VEILING AND LIFTING	120
Demonstration: Watermelon Woman	*122*
TRANSPARENCY	130
PRINTING	134
MARK-MAKING	144
Demonstration: Red Lilies	*168*

Varnishing and completing — 174

INDEX	176
Acknowledgements	

Rocky Road
Shown in full on page 45.

INTRODUCTION

This book is aimed at experienced and professional artists who wish to improve their skills, are just starting out on the abstract journey, or are eager to explore new techniques and materials but are unsure of where to start. Beginners may also benefit from a fresh outlook on more conventional methods as they may be at the stage where they are searching for different, exciting ways in which they can interpret their newly acquired skills.

The book is divided into thought-flowing chapters that will, hopefully, encourage new experiments and methodologies within the scope of the artist's own imagination. From investigating the art of the abstract with the use of colour, collage, composition, design and interpretation, we will move on to explore the plethora of tools and materials available, and how to employ them using mixed-media techniques. We then move on to experiment with the wonderful joy of mark-making and investigate ways and methods in mixing the media.

Throughout this book I offer insights and ideas on the way I personally work. My aim, and the book's purpose, is to encourage you to experiment and formulate your own way of working, incorporating your own thoughts and processes to create unique pieces of art. Use my ideas as a launch pad to adopting your own personal style and artistic voice.

Let's start the journey!

I Play on My Piano 30 × 40cm (11¾ × 15¾in)
Collage, acrylic, clear gesso, soft pastel and Indian ink on mixed-media paper.

ABSTRACTION VERSUS REPRESENTATION

One dictionary definition of 'abstract' is 'an art form that represents ideas (by means of geometric and other designs) instead of natural forms'. My own interpretation of abstraction is an experimental process that allows a painting to take a turn of its own, removing any trace of representational imagery. The piece will then evolve intuitively or as planned and form its own affinity with the viewer.

Conversely, my interpretation of representational art is to present the viewer with a recognizable subject that is depicted in a more abstract form than that of realistic representation or photo-realism. This method can prove to be very exhilarating, fun and playful, and can provide a fresh approach to a more traditional painting style. Changing colours, form and dimension to create an 'essence' rather than a representation of reality can be very freeing and expressive, as illustrated in *Horse Power*, below.

Horse Power
30 × 24cm (11¾ × 9½in)
Gouache, acrylic ink, clear gesso, soft pastel, acrylic and pastel pencil on Pastelmat paper.

WHAT IS MIXED MEDIA?

Years ago, when I first started out on this fascinating mixed-media journey, most artists were using either oils, pastels, charcoal or graphite, and I was no exception. However, as I became more curious about the materials on offer, I noticed that there was an influx of paintings emerging using the term 'mixed media'. This term gripped my imagination, and I started to delve deeper into the subject.

These days, we are very lucky to have so many products to work with and at a reasonable price; but, where to start? In terms of what can be achieved under the umbrella of mixed media, almost 'anything goes'. However, care must be taken to observe specific technically-proven processes that do not work, such as using acrylics over oils – although oils over acrylics work perfectly and many artists use acrylics as an underpainting because of their fast drying times.

Examples of mixing the media

These are just some of the examples that you can play with on your journey – this list is by no means exhaustive.

- Texture pastes and gels can be used to create an interesting surface;
- All forms of water-based media work particularly well together (acrylics, inks, watercolour, gouache, pigment sticks and so on);
- Collage can be combined with almost any form of paint;
- Dry media can be added to create accents and interest to a piece;
- Soft and hard pastels can be used together;
- Oil pastels and oils work well over acrylics and other media (see above).

Twilight 41 × 41cm (16 × 16in)
Acrylics, texture pastes, collage and oil pastel on canvas.

INSPIRATION

I am never stuck for inspiration; in fact, sometimes I have too much, and it can be overwhelming not knowing where to start. When this occurs, I usually make notes in a journal or sketch out some rough ideas to come back to once the chaos has settled and the mind is free once more.

From left, Brook Beach, Isle of Wight; backwater at Staithes, Yorkshire coast; lobster pots, Staithes Harbour, Yorkshire coast – all UK.

SOURCES OF INSPIRATION

Besides the obvious subject of nature, any visual stimulus such as a gesture, a structure, an angle, a colour combination, a pattern or texture, cracks in the pavement, rock strata or even a scene on television offers potential to kickstart the creative thought process. I am also a lover of text and inspirational writing, poetry and quotations, and am particularly drawn to interesting fonts and handwriting. These I can incorporate into my work as collage elements.

Find poems, book passages and inspirational quotes that resonate with you and use them as a basis for your painting. If you are using the original words in your art, do remember to check whether they are subject to copyright.

Research other artists whom you find interesting – what is it about their work that draws you to them? Create some studies emulating their style to free you up in a different direction. However, be careful not to get too reliant on someone else's approach – you are looking to develop your own personal style rather than an imitation of another artist's style, so use this exercise to lead you to other possibilities that you had not thought of before. I sometimes do this when my work is becoming repetitive and I feel the need for a different approach.

It's also interesting to look back on your old paintings to see how your techniques and interpretation have changed over the years. Sometimes I see a technique or effect that I had completely forgotten about and which I am able to reintroduce into my new works.

Be ready...

Inspiration can arrive very unexpectedly so it's important to be ready with a sketchbook, camera or even a pen and paper, to record the moment for later use. Some artists always carry a sketchbook with them to jot down ideas that can be referred to later.

I usually tend to photograph these revelations rather than sketch them, unless I am on an art holiday or retreat, when I will sit and sketch for hours in a travel journal. Occasionally I use these references for a larger painting or to get back that sense of place and atmosphere.

Like many creatives, I can suffer from artist's block; in fact this happens quite often, especially after I have exhausted all present possibilities in a prolific series of work. Normally, instead of agonizing over what to do next, I will either sort through my studio and see what reveals itself to me, or I will find an object and paint that object in different styles and colours, paying no attention to detail – just aiming to get paint down on the paper and create.

Try to see everyday objects with new eyes and from a different perspective.

It's amazing what can happen in these carefree moments. Often, I will start a work only to be led down a totally different path, abandoning what I first intended, and embark upon an entirely different route, subject or approach. I may come back to my original thoughts at a later date and finish the piece. The secret is not to get too precious about what you want to achieve and instead abandon yourself to the muse within – a leap of faith is sometimes needed.

Pinterest is a great platform for inspiration; I for one am addicted to it and have created over a hundred boards. It must however be stressed that this is merely a platform from which to form your own ideas; the ideas are not to be imitated or copied – not just because the images will probably be subject to copyright, but also because the purpose of creating is to discover your own voice and style. If I require reference photographs, I use a site called Unsplash, which provides copyright-free images and is free to join.

Other sources of inspiration:

- Music – which colours evoke movement, form, atmosphere, emotion?
- Countries of the world – traditions, religions, food, dress;
- Inspiration from the climates of the world – greens of Ireland, heat of India, spices of Morocco, snow and ice of Antarctica, and so on;
- Weather – a rainy day in the UK, thunder, lightning, storms, sun, wind and rough seas;
- Events – carnivals, regattas, fairgrounds;
- Gardening and flower catalogues.

Left: One of my travel journals, consisting of quick, lively sketches evoking memories and scenes of a road well travelled.

THE TOOLMAKER

The inspiration for this abstract painting came from a mixture of tools hanging on a restaurant wall in Sicily.

I was fascinated by all the shapes and the negative space around them. I felt that these were the perfect inspiration for an abstracted still life painting. I started work on this the day after I returned from holiday as it excited and motivated me.

I decided on a neutral colour palette, a 40cm (15¾in) square format on canvas board and a cruciform composition (see page 36), all reminiscent of the tools on the whitewashed walls.

Photographs of various carpentry tools hanging on a wall in a restaurant in Sicily provided inspiration for this painting that uses neutral colours.

MATERIALS AND TOOLS

Surface: Primed canvas board, 40 × 40cm (15¾ × 15¾in).

Materials: PVA glue; neutral-coloured collage papers; paper ephemera; charcoal; white gesso; corrugated card; acrylic gel medium; black Indian ink; acrylic paints in yellow ochre, Payne's gray, indigo and white.

Tools: Tear-off paper palette; flat paintbrushes; bamboo skewer; circular stamps or bottle tops; old draughts (checkers) piece or similar item; stencil; cosmetic sponge; isopropyl alcohol and kitchen paper.

1 I covered the board entirely with torn-up, neutral-coloured papers and ephemera in a random fashion. As this was quite a large area to cover and some of the papers were robust, I used PVA glue, slightly diluted with water, to attach the papers.

2 I mapped out my composition in charcoal, based loosely on the original reference photographs.

3 I stabilized the charcoal lines by blurring them with undiluted white gesso on a brush to get a feel for the composition and placement of elements, and to give me a basis on which to work.

4 I blended a thin layer of white gesso over the whole piece with a damp sheet of kitchen paper. This gave me a starting point on which to build up the collage layer.

5 I then added some textured collage in the form of cut corrugated card and adhered this with acrylic gel medium towards the centre of the arrangement.

6 I began to establish the composition by creating shapes with indigo and Payne's gray acrylic paint, and blocked in some of the negative shapes using yellow ochre.

7 I reinforced the composition by outlining the shapes with charcoal.

8 I scratched into the wet paint with the end of a paintbrush to create energy and movement. You could use a bamboo skewer (right) or even a scalpel blade if the paint has dried.

9 I added design elements by stamping circles with the edge of a bottle top dipped into black Indian ink at the top left and bottom right.

10 At this point I stood back to observe the painting, to see if any obvious forms stood out. I could make out the form of a figure emerging, which was quite by accident and exciting, and why I work intuitively with no set goal in mind. Using white gesso around the negative spaces, I accentuated the silhouette of this form and created a great contrast between the lights and darks. I created further contrast by adding yellow ochre mixed with white in other areas to provide a good range of tones and values.

11 I applied more marks with other circular objects, brushed with paint. In this case I used an old draughts (checkers) piece, brushed with yellow ochre.

12 To set the scene even further, I painted in a keyhole symbol with black Indian ink on the upper-right third of the painting.

13 I applied more scratches with the end of a skewer in static areas.

14 Finally, to give the piece a more cohesive design, I selected a stencil with a geometric pattern, through which I applied more colour in various places using a cosmetic sponge.

The Toolmaker 40 × 40cm (15¾ × 15¾in)
Using geometric form and an innovative thought process to create an abstract painting based on a composition of a mixture of tools.

THE ART OF THE ABSTRACT

UNDERSTANDING THE CREATIVE PROCESS

To understand what makes the creative process work, we need to look at its myriad components, from colour, composition, design elements, tools, materials and application – all of which are employed to create a dynamic finished piece of art.

Throughout this chapter, we discuss all aspects of using colour, making colour choices and selecting colour palettes to work from. We then move on to create exciting compositions that will enhance and give meaning to our work. Throughout, demonstrations will illustrate how reality can be transformed into an abstract form.

Finally, we explore different approaches to the order of our work, and look at how to make the best decisions to generate a successful, finished piece of art.

Brook Beach 50 × 50cm (19¾ × 19¾in)

Mixed media on stretched canvas, with acrylics, Brusho, collage, scrim (surgical gauze), acrylic ink and oil pastel.

This coastline, along the Isle of Wight, UK is abundant with fossils and other prehistoric finds such as dinosaur footprints, I have included a small image of a fossil and included the word 'Jurassic' in the form of collage to convey this to the viewer.

COLOUR

Well, what a subject. This topic has been researched and documented for decades and we can see its theories and results in the indispensable colour wheel. It is thought that Sir Isaac Newton (1642–1727) created the first colour wheel when he was experimenting with prisms and came up with the theory that red, blue and yellow were primary colours, from which every other colour was derived.

The purpose of the colour wheel is to display the relationships between colours, to produce a pleasing and aesthetic palette. The wheel is cleverly laid out to provide the user with a choice of workable colour combinations, all of which are identified on the wheel. There is a suitable combination of colours to suit almost any given requirement. The skill lies in the decision of where to use which combination for maximum effect.

Colour plays the starring role in all works of art, be it a cacophony of explosive pigments or more simplistic renderings in humble black and white. We use colour to express tone, light, harmony, movement, contrast, mood, drama, pattern and form.

A mixed-media colour wheel.

There have been many movements in the art world that use colour in expressive ways – here are just a few:

- **Old Masters** As colour supplies were limited, artists in the fourteenth to seventeenth centuries relied instead upon dynamic composition, and the power of light and dark juxtaposed against one another, to create effect. Proponents include Leonardo da Vinci (1452–1519), Albrecht Dürer (1471–1528) and Michelangelo Caravaggio (1571–1610).
- **Impressionism** Late nineteenth-century artists such as Claude Monet (1840–1926), Edgar Degas (1834–1917) – and Vincent van Gogh (1853–1890) in his early works – used a softer palette of pastel hues to convey mood and atmosphere. Their works were usually painted *plein air*, which had not been possible before the availability of new pigments and paints in tubes.
- **Fauvism** The early twentieth-century Fauvist artists – including Henri Matisse (1869–1954), Georges Braque (1882–1963) and André Derain (1880–1954) – used pure, brilliant colour straight from the tube in aggressive and explosive ways.
- **Expressionism** Early twentieth-century artists, such as Edvard Munch (1863–1944), Wassily Kandinsky (1866–1944) and Gustav Klimt (1862–1918) used colour to express feelings about a subject rather than painting it in a more naturalistic way.
- **Pop Art** This was a new and bold movement wherein artists used flat primary colours in a confident fashion, usually separated by thick black lines. Examples of Pop Art can be seen in the works of Andy Warhol (1928–1987), Keith Haring (1958–1990) and Roy Lichtenstein (1923–1997).

Today we are fortunate to have the knowledge and capability to produce vibrant pigments that were unavailable to the past Masters. So, I urge you to exploit this wonderful gift and give yourself permission to 'run riot'.

MAKING INTUITIVE COLOUR CHOICES

The great thing about abstract-representational painting is that there are virtually no rules about colour. You do still have to know how colours work together, but once you've grasped the concepts, it's time have some fun trying out previously unconceived colour combinations.

I now suggest you put away the colour wheel and play. In the following exercises, I encourage you to seek out combinations that you wouldn't usually use, or that go against what you previously thought were 'safe'. Why not paint the sky green or red; why not paint the sea pink, or even yellow? I sometimes try out unconventional colour combinations as a warm-up to an actual painting by creating mini abstracts such as those shown below, left.

Divide a sheet of watercolour or acrylic paper into sections and paint each one in a different colour (I've used acrylics, but you can use whichever media you like). Allow them to dry, then go in with another colour in a larger shape and then two other smaller colours close by.

What do you see? What do you like; what makes you go 'ooooh!'?

Don't spend too much time thinking about it and avoid the temptation to refer to the colour wheel! Remember that these are experiments, which can become quite addictive.

You can either keep the exercise fully abstract or reproduce some form, as in the flower bud example, below left. The choice is yours.

Representational studies based on a flower bud.

Look at the juxtaposition of colours for effect – see what happens to a colour when another colour is placed beside it.

I find that keeping to a similar format or composition within these studies makes for better comparisons than having different forms which could be confusing – we are focusing entirely on colour relationships here, not on the subject itself.

Twilight

This painting, seen also on page 9, was inspired by colour study number 2, top row, on the left.

Seeking inspiration?

Sites such as Pinterest can be a great source of colour inspiration: search for 'colour palettes' – there are so many beautiful combinations to be seen. Browse magazines and catalogues, keep a scrapbook of colours you are drawn to and try out these combinations following the exercise in colour choice, above.

CREATING ATMOSPHERE AND MYSTERY

Dark, brooding colours such as indigo, Payne's gray and viridian green may seem to be the obvious choices to evoke mystery, while lighter colours such as yellows, pinks and other pastel shades can create an ethereal atmosphere bordering on fantastical. However, it is possible to create both of these moods using other colour choices, by applying the colours in different ways to enhance the subject and create the mystery in the viewer's imagination.

Using the primaries

In these two paintings, below and opposite, I had no preconceived ideas as to what these paintings would become. I started to apply primary colours in a fast and random fashion, paying attention only to possible composition elements. Other colours naturally appeared where the primaries overlapped. These two examples show how basic colour choices can create atmosphere and mystery without complication.

The Lone Tree 25 × 25cm (9¾ × 9¾in)
Here, the darker colours provide the mystery while the lighter colours serve to enhance it. I inscribed marks into the wet paint with the end of my brush to create an ethereal feel, and noticed that the collage element on the upper right suggested a bank of trees, which I enhanced with a sweep of green. I painted the single tree using one stroke of a rounded brush to establish a focal point.

This composition and playful use of colour serve to trigger the imagination, while fast and loose application of the paint gives the piece its own energy.

Across the Lake 25 × 25cm (9¾ × 9¾in)

Here, I used the same process as for The Lone Tree, *opposite, resulting in a completely different effect. I lightly brushed white gesso over the lower-right area to suggest a mist moving across the lake, giving the subject a mysterious quality, while the silhouetted trees add even more to the drama.*

COLOUR PALETTES

Divide a large piece of paper into three or more sections and select colours that you wouldn't normally use. I suggest three colours at the most, plus a black and a white. Keeping these studies together on one piece of paper allows you to make different choices on how you apply the colours, as in the examples below. Keep it simple. Play around with composition and mark-making and ways of applying paint; don't think about what you are doing, just have fun.

> **Tip**
> If you are unsure of how a colour will look, try using that colour in the form of a piece of collage – you may even decide to keep the collage element in the painting instead of using paint. For instance, yellow paint is notoriously difficult to lay over other colours so a piece of yellow collage could be the answer.

What did you notice about using these colours – what colours appeared when the different hues mixed naturally together on the surface? Will you use these colours again in your work?

Greens can sometimes be problematic for me as it can be hard to find just the right shade or hue of green that will work harmoniously with other colours, so these experiments pushed my boundaries a little; nevertheless, I found that I actually enjoyed working with them in this way. I chose three different compositions and used red as my focal point in the first two and as an accent in the third, where I introduced a blue-green background.

> **Tip**
> Accentuate a focal point by placing accent colours nearby or around it.

Working with a limited palette

Although I adore colour, I still usually use a limited palette of three or four colours (plus a black and a white), adding bright accents in certain places – usually around a focal point. However, I have also been known to go a bit crazy with colour – as in the example below. Restricting the colours in this way not only allows you to keep your colour-mixing simple and effective, it also stops the risk of making 'mud'.

However, restricting your palette doesn't mean you can't mix a colour of different properties, such as a warm and a cool hue – think of ultramarine blue and cobalt blue, cadmium red and scarlet, lemon yellow and Naples yellow, and so on. These mixes will give you potential for even more choice and variety while still maintaining harmony within the spectrum.

Magenta Sky 25 × 25cm (9¾ × 9¾in)
Texture paste and acrylic on watercolour paper.

The inspiration here was taken from a soft furnishings catalogue. At first glance, this painting showcases a far-from-limited palette; however, on closer inspection, you will see that I have used only primary colours to produce a vivid, colourful finished work.

Tip
Tone down too bright an area with neutrals, or a complementary colour.

Neutrals

While I am an avid lover of colour, I recognize the importance of grounding neutrals to strengthen and complement a piece. Neutrals are often overlooked, although I use them often to establish a solid base on which to build colour and form. I also use them to enhance the vibrancy of juxtaposing colours, making sense out of chaos, creating a calming influence amidst a blaze of dynamic effects.

Here, we look at creating a painting through neutrals alone, with just a hint or accent of colour around the focal point.

The Meeting 50 × 50cm (19¾ × 19¾in)
Acrylic, texture paste, collage and charcoal.

A WORD ABOUT BLACK

For a long time, black was considered taboo in the art world, as it was deemed a 'dead' colour that reflected no light, making a painting look dull and lacklustre. Artists used a combination of blues and dark browns or a mix of complementary colours to create a more pleasing dark that enhanced rather than took away from their work.

However, in the world of abstracts and mixed media, black can be a valuable tool – both Matisse and Manet were keen users of black. I especially like to use it in collage form to create bold contrasts and black lines to give definition (see *Urban Symphony*, opposite), while using a glossy black paper (as a contrast to matte paper) can enhance a focal point and add interest, as shown in *Through the Keyhole*, opposite.

Interestingly, there are still warm and cool properties to be found in certain black paints – for instance, lamp black is deemed cool, and ivory black, warm.

Tip
Harness the power of black and white – Op Art (optical art) is a great example of showcasing the power of 'no colour'.

Urban Symphony 50 × 50cm (19¾ × 19¾in)
Acrylic, texture paste, collage, charcoal, white gel pen.

Through the Keyhole
27 × 28cm (10⅝ × 11in)
An example study of using black as a collage element and focal point in an abstract painting.

ROCK STRATA

In the demonstration below, I have chosen to use a local colour scheme that you would expect to find in rock formations. I decided to use earth tones for this first study, as the shapes inspired an abstract landscape feel.

Had I chosen a blue colour palette for the study, then the mood would have changed completely to reflect a seascape effect rather than a landscape effect – as can be seen in the abstract seascape demonstration, *The Meeting of the Waters* (see pages 30–35), which was also based on a reference photograph of rock strata. Feel free to experiment with colour and consider what your colour choices say to you.

Reference photograph courtesy of Antoniela Ginourie.

MATERIALS AND TOOLS

Surface:: Acrylic paper, 36 × 25cm (14¼ × 9¾in).
Materials: Charcoal; white gesso; dressmakers' pattern paper; acrylic paints in burnt sienna, yellow ochre, cadmium yellow, titanium white and Payne's gray; black Indian ink; yellow liquid watercolour ink; pink oil pastel and matt medium.
Tools: Kitchen paper; flat brush; pipette and tear-off paper palette.

1 I sketched in my loose composition with a black charcoal stick, and moved the lines around with white gesso to create blurred, organic shapes. This formed an underpainting.
2 I began to apply acrylic colour in burnt sienna, cadmium yellow and yellow ochre, randomly mixing and blending the paint to create the undulations of the landscape. I used Payne's gray to outline the hills.
3 I adhered pieces of creased-up dressmakers' pattern paper with matt medium in places to create some texture.
4 I knocked back some of the darker areas and the sky section using white gesso on a damp piece of kitchen paper. I let this dry before adding more gesso to veil certain areas of the painting (see pages 122–125) and lightening the left hill with a thin layer of titanium white.

5 Next, once everything was dry, I gently squirted Indian ink across the paper with a pipette and pulled out some of the ink lines, drawing freely with the end of the pipette. Again, I left this to dry.

6 I brushed a sweep of yellow liquid watercolour ink lightly across the top of the hills to emulate a sunrise.

7 I then introduced the same colour into the bottom left for harmony and allowed this to dry once again.

8 Finally, I dragged a pink oil pastel across the creases in the pattern paper and above the horizon line and hill shapes to enhance the sunrise effect.

Rock Strata
36 × 25cm (14¼ × 9¾in)
Fissures in the rock strata were transformed into an abstract landscape using imagination, vision and creativity.

THE MEETING OF THE WATERS

In this demonstration, I will be using primed watercolour paper to create a seascape based on the photograph of rock strata on the right. I will be using the lines in the rock to represent the waves in the sea.

Reference photograph courtesy of Antoniela Ginourie.

MATERIALS AND TOOLS

Surface: Primed watercolour paper, 42 × 30cm (16½ × 11¾in).

Materials: White gesso; charcoal; blue Inktense pencil; resin sand texture paste; black Indian ink; turquoise Brusho; marble effect spray; acrylic paints in ultramarine blue, Prussian blue, cobalt blue and cerulean; scrim (surgical gauze); matt medium; collage papers (comprising suitable words) and white oil pastel.

Tools: Kitchen paper; flat paintbrush; pipette; palette knife; water in a spray bottle; isopropyl alcohol in a spray bottle and a hair roller.

1 I primed the watercolour paper with a coat of gesso, then, once dry, drew in lines with charcoal and a blue Inktense pencil.

2 I spritzed the lines with water – using the water bottle – to create runs, then allowed to dry.

3 I then applied some resin sand texture paste with a palette knife to the bottom area and again allowed to dry.

4 I decided to work with a blue monochromatic colour scheme for this seascape, but greens and turquoises would also have worked well. I began to block in the main shapes with Prussian blue.

5 I then blocked in the wave shapes with ultramarine and cerulean blue.

6 While the paint was still wet, I drew into it with the end of my paintbrush to make dynamic marks.

7 I knocked back the wave shapes with white gesso, applied with a damp sheet of kitchen paper.

8 I squirted lines of Indian ink across the paper with a pipette.

9 I then pulled out some of these lines, drawing freely with the end of the pipette.

10 I sprinkled over some turquoise Brusho with a palette knife and activated the pigment by spraying it with water, to emulate the feeling of rough seas and waves.

11 Once the Brusho had dried slightly, I spritzed over it with a little isopropyl alcohol to achieve an organic impression of water – the surface of the wet Brusho needed to dry slightly before the alcohol would work. You can experiment on a separate piece of paper to familiarize yourself with this technique.

12 I added some more white gesso to the waves by dragging it with a palette knife to create some texture.

13 I adhered pieces of torn scrim (surgical gauze) with matt medium to the upper-right and lower-left areas, to suggest fishermen's nets.

14 I selected some collaged words to describe the scene – I chose 'Neptune', 'Power' and 'The meeting of the waters' – and adhered them in places with matt medium.

15 Using a dry brush, I dragged white acrylic paint over the foreground sand texture.

16 I scumbled white oil pastel over the scrim.

17 I then applied a thick coat of white acrylic paint with a palette knife, over the crests of the waves.

18 I dragged a hair roller through this paint to create the movement and energy of the sea.

19 Finally, I masked off the upper part of the painting with a piece of kitchen paper to protect the area, and lightly sprayed over with marble effect spray to produce web-like marks, representing the splashes of the waves.

The finished painting can be seen overleaf.

Further colour tips

- *Keep colours vibrant and layer rather than blend; a colour is at its brightest straight from the tube.*
- *Use black and white photographic filters on your phone to check the tonal value of your painting. Aim for a good range of values to create tonal contrasts.*

The Meeting of the Waters
42 × 30cm (16½ × 11¾in)

THE MEETING OF THE WATERS

Power

COMPOSITION

Composition has to be one of the most important aspects of creating a painting, if not, *the* most important aspect. Without composition, the work would have no substance, depth or aesthetic value to the viewer.

In abstract work, composition can be elusive; there appears to be no single element to steer you in the right direction. Jackson Pollock, for example, did not seem to use any form of basic composition but used gesture and rhythm in his paintings to create an unique style and visual excitement.

Compositional formats for representational paintings, such as landscapes, on the other hand, are easier to understand as the subject will determine the composition for you.

So how do you decide on a composition for an abstract painting? My first priority is to decide on what I want to convey: how the various elements will fit together and unify the finished piece. Sometimes I will decide on the composition first and then assemble the different components to fit in with the choice I have made. At other times, I will let the composition develop intuitively as the painting progresses.

PRINCIPLES OF COMPOSITION

Compositional formats

Most of you will already be familiar with basic compositions, but how many of us seem to always stick to the same, safe format? I have to admit that I am very drawn to the cruciform composition in my abstract work and sometimes have to force myself to try other alternatives, of which there are many more.

Choosing the right composition is a crucial factor when creating abstracts as it gives the piece meaning and stability within what could quickly become a disjointed order of an abstracted concept. The following compositional formats give me a starting block on which to build when creating both abstracts and representational pieces. There is no logical reason why I choose these compositions; they just seem the right way of working for me.

You may find other compositions equally pleasing, so experiment, and do not overthink the process.

CRUCIFORM

A dynamic compositional format dividing the painting into a cross shape. Usually, each quadrant of negative space is of unequal proportions while the main focus is concentrated within the cross which will also contain the focal point. Examples of this composition can be found on pages 26–27, in *The Meeting*, and *Urban Symphony* – the latter is shown on the right.

TUNNEL OR 'S' CURVE

As the name implies, the viewer's eye is led into the painting by way of a tunnel or curved structure that takes the viewer on a journey. You can see an example of this composition in the painting *Lobster Pots*, on page 77 and below.

LOW OR HIGH HORIZON

These are very popular compositional choices: a low horizon gives dominance to the upper section of the painting, while a high horizon will give dominance to the lower section.
See *Cottages at Penmon: Penmon 1* on page 49, and below, right, for examples.

OVERLAPPING FRAMES

Using geometric shapes in various sizes, a composition of overlapping frames can arouse interest and narrative. See *March of the Sunflowers*, below, for an example of this format.

March of the Sunflowers
40 × 30cm (15¾ × 11¾in)
Mixed media on paper, based on the Overlapping Frames composition, above.

THE GOLDEN SECTION (RULE OF THIRDS)

This is one of the most prolific compositional elements in any form of art. This format is based on nature: by placing elements of the composition within individual thirds on the substrate, an aesthetically-pleasing alignment can be achieved. *Backwater at Staithes*, below, features this composition; you will see immediately that the piece is divided into thirds.

Backwater at Staithes
30 × 40cm (11¾ × 15¾in)
Mixed media on paper based on the Golden Section composition, above.

PLAYTIME WITH MATISSE

Now, for a bit of fun, we're going to explore the simple fusion and combination of shapes to create some visual vocabulary and studies in the style of Matisse's cut-outs.

Henri Matisse (1869–1954) was a French artist, known for his use of colour. The intense colours of the works he painted between 1900 and 1905 brought him fame as one of the best-known artists in the Fauvist movement. When ill health in his final years prevented him from painting, he created an important body of work in the medium of cut paper collage, which he referred to as painting with scissors.

MATERIALS AND TOOLS

Surface: Mixed-media or watercolour paper, 21 × 29.7cm (8¼ × 11¾in).

Materials: Pastel primer; plain-coloured papers; thin cardstock; clear gesso; soft pastels; black charcoal; Indian ink and acrylic paint.

Tools: Scissors or craft knife; flat brush; cotton bud (cotton swab); plastic bottle cap; spray bottle and cap; cosmetic sponge; PVA glue; spray fixative and isopropyl alcohol.

1 Find any plain-coloured papers or thin cardstock that you have in your 'stash' and cut them up into various shapes, some geometric and others organic. Start to create random designs on a white piece of paper. Make some shapes overlap and others stand alone. Once you find a pleasing composition, photograph it for reference.

2 Coat your mixed-media paper with clear gesso or pastel primer, as you are going to add and blend soft pastels, which will need a toothed surface to adhere to.

3 Glue down your shapes, referring back to your reference photograph if necessary, and coat them with clear gesso.

4 Start to add soft pastels, blending the pigments with a blender, cosmetic sponge, cotton bud (cotton swab) or your fingers.

5 Outline some of the shapes with black charcoal, then spray the paper with fixative to fix the pastel in place.
6 Stamp some circles over the composition using a plastic bottle cap dipped in Indian ink.
7 Try adding in a coat of acrylic ink and dropping in some isopropyl alcohol to create some organic marks – here, I'm using the inner tube of a plastic spray bottle to draw into the acrylic ink with the alcohol. Blot the liquid, then go back over with pastel.
8 Finally, reinforce the lost colours on the shapes with acrylic paint and incorporate a little mark-making with Indian ink in various places in the piece to pull the design together.

These mini-collages are a great source of entertainment and at the same time present you with ideas on abstract compositions and colour profiles. They are also a good way to warm up to a complete painting; some compositions may even become paintings in their own right – slide a viewing mat over the finished collage to see if different parts of the piece give better results.

Another exercise to try is to use the same inspirational idea with different compositional styles; this is a particularly useful practice when working on a series.

The finished composition.

DESIGN

Striking balance, harmony and unity

Now we have refamiliarized ourselves with the principles of composition, we can investigate what else makes a painting interesting and appealing. By applying one or more principles of design to our work, what once seemed to be a chaotic jumble can be transformed into harmony, create impact and add excitement.

Again, you will have a general idea of these principles and some of you may even employ them intuitively, but it makes sense to revisit these old friends and maybe see them in a new light.

Principles: Balance, unity and harmony, contrast, rhythm, repetition, gradation, dominance.
Elements: Line, shape, pattern, space, value, colour, size.

These principles and elements of design have been researched and documented in great depth and they serve to guide and assist the artist by working together to produce visual harmony in the execution of a painting.

ROCKY ROAD

An exercise in design

Make some compositional studies using paint and collage. Pay attention to the various elements that will make up the design.

MATERIALS AND TOOLS

Surface: Mixed-media paper, 36 × 26cm (14¼ × 16¼in).
Materials: Oranges, greens, violets, yellow ochre, titanium white and sand acrylic paints; phthalo green-yellow fluid acrylic paint; mixture of collage papers (plain and patterned); matt medium; black Indian ink and green and orange oil pastels.
Tools: Squeegee; flat brushes; pipette; viewing mat and tear-off paper palette.

1 I began this demonstration with a tunnel composition in mind and with a triadic colour choice of orange, green and violet as the main colours in the study. I began by dragging a light orange and green acrylic paint over mixed-media paper using a squeegee to give an uneven effect and add some texture.

2 I started to adhere torn collage papers with matt medium in parts to create the structure and the basis of the composition.

3 I continued to add collage papers to build up the composition and design. I then applied a thin layer of phthalo green-yellow fluid acrylic into the bottom right and top left of the composition to create a glazing effect, and a deep orange in places for contrast.

4 While the paint was still wet, I scribbled in lines with the end of the paintbrush to make energetic marks.

5 I continued to build up the paint layers with a mixture of yellow ochre and titanium white to provide even more contrast and lighter areas.

6 Once the painting was dry, I added design elements with black Indian ink drawn and scribbled in with a pipette. This application would serve to create some form and a variety of shapes.

7 I added more lights using sand acrylic paint, and again scratched into the wet paint with the end of the brush to make more dynamic marks.

8 At this point, I stood back to observe the direction in which the painting was developing. As a result, I added more collage elements to break up the larger forms, using circular or geometric patterned craft paper to introduce some complementary marks and shapes.

9 I then introduced the third triadic colour of violet mixed with white and applied this to some of the smaller areas of the piece.
10 I defined the design further by adding a repetition of lines and circular shapes with green and orange oil pastels.
11 At this near-complete stage, I placed a viewfinder over the painting to select the most pleasing areas to finalize the piece.

Rocky Road 36 × 26cm (14¼ × 16¼in)
In the closing exploration, you will note that what started out as a tunnel composition changed into a more asymmetrical or off-balance one. However, the repetition and variety of shape and line gave the study unity, balance and contrast.

Break the rules

Don't feel that you have to follow the rules rigidly all the time; breaking them can be fun and liberating. Break the rules with deliberate intent to see what can be achieved and what works for you. Base your composition, colour, focal point on the guidelines but adjust them slightly to see what happens and to make an individual statement.

It is said of figurative paintings that you should never depict a person looking outside the canvas, but it could be argued that their stance raises questions: what is the person looking at? Does their stance convey a specific mood?

Another such rule is that elements should always appear in an odd number, apart from two; however, even numbers grouped together can be even more dynamic, such as a group of six split up into one and five, or three, two, one can convey a different story altogether.

'Never place a focal point in the middle' – how do you explain the appeal of mandalas?

There are always exceptions…

INTERPRETATION

There are many ways to interpret your subject matter, be it inspiration from reality or something conjured up in your head. You will also find that individual viewers will often form their own interpretation of the subject, which is very different from what you originally intended. This is why I find creating abstract art so fascinating and exciting.

In the demonstration below, you will see how I've used the patterns and shapes in pavement cracks as a basis for a study in abstraction. Studies such as this can then be used as inspiration for larger paintings, or even small pieces of art in their own rights.

The reference photograph.

POLLEN FOR THE BEES

MATERIALS AND TOOLS

Surface: Canvas sheet, 20 × 29cm (8 × 11½in).
Materials: Charcoal; white gesso; acrylic paints in lemon yellow, violet, pale green, titanium white and Mars black; Indian ink; acrylic ink in primary yellow; lace paper; glass bead gel; yellow and green oil pastels and matt medium.
Tools: Flat brush; pipette; viewing mat or viewfinder and palette knife.

1 I drew in the pattern of lines with charcoal and smudged these with white gesso.

2 I chose three colours here – yellow, lilac and green acrylic paints – for a vibrant effect, plus black and white. I started to block in the shapes, mixing some colours with white and some with a tiny bit of black to create a good range of tone.

3 I went over the lines with Indian ink applied through a pipette, and allowed the ink to run as I tipped the paper in different directions. I then allowed the ink to dry before continuing.

4 I strengthened the yellow areas, using primary yellow acrylic ink as a glaze.

5 I then introduced texture in places by adhering torn lace paper using matt medium.

6 I moved around the viewfinder to select the best composition. I decided that this piece was taking on a floral feel, so I decided at the next stage to add some glass bead gel to represent a flower centre.

7 Using a palette knife, I applied a coat of glass bead gel to the central shape and left this to dry overnight.

8 Once the gel was dry, I scumbled over the beads with a yellow oil pastel to represent the stamens, then made marks with green oil pastel in places to finalize the piece.

Pollen for the Bees Cropped: 20 × 20cm (8 × 8in)
The finished demonstration.

WORKING ON A SERIES

Beginning a series of paintings based on a single theme or reference photograph is one of many ways in which you can interpret a subject, and this can be quite liberating. Look at different ways in which you can construct a painting from the same source: changing the composition, colour, shaping and so forth. I start off by creating a sequence of studies to get in the mood, to refine my composition and colour options and use it as an excuse to let go and have fun.

Work spontaneously with no set goal in mind – this makes you receptive and frees you up to make changes and to experiment without fear of failure. These are purely studies, so use them to see what works and what doesn't: learn to cover up any mistakes, or use them as 'happy accidents'.

A warm-up exercise

It's good practice to carry out some quick warm-up exercises before you embark on bigger works. These get you in the zone and are good ways to loosen up and play. You may be surprised at the vast opportunities open to you.

Create a few fast and loose thumbnails based upon familiar objects and try to see them in a different way. Look for pattern and negative shapes, change the orientation of the object if you like, be as whimsical as you want to be.

I used the image of a cut pepper as my familiar object in the exercise below, and worked with acrylic paints, but feel free to use whatever media you like. Collage is a good example, as you can play with different approaches and colours before gluing the papers down. The objective of the exercise is to get used to seeing everyday objects in different ways as a precursor to larger abstract works.

I use this exercise regularly in my studio practice and suggest you do the same – it's great fun and can be very rewarding.

Cottages at Penmon – Anglesey, Wales

I visit Anglesey often as it's only a two-to-three-hour drive from home, and I always get inspiration from two small fishermen's cottages that overlook the lighthouse at Penmon. The surrounding area is quite stark, with shale and stone forming the landscape and dramatic skies creating atmosphere and mood. Here, I've used a series of three approaches on watercolour paper to represent the cottages in different ways.

In the first painting, below, I have used a high horizon composition in landscape format. I used collage to sculpt form and resin sand for texture, and chose a colour palette of yellows, pinks and purples in acrylic paint.

Penmon 1 40 × 30cm (15¾ × 11¾in)

Penmon 2 30 × 30cm (11¾ × 11¾in)

In the second painting, above, I decided to opt for the overlapping frames composition (see page 38) within a square format, using collage to sculpt form once again and crumpled tissue paper to create texture. My chosen colour palette here was: neutrals with accents of blue and green in acrylics, with highlights using acrylic ink and oil pastel. I used stamps coated with black acrylic paint to balance out the design elements.

In the third interpretation of the subject, opposite, I decided to extend the perspective composition to make the painting more abstract, using a horizontal format, collage to sculpt form and scrim to create texture. The colour palette I chose in this instance comprised pinks, blues and greys. I added highlights with circular bottle-top stamps and bubble wrap in white acrylic, added a stencil of a circle representing the moon and a piece of text reading 'Transform' to give the abstraction some meaning.

Penmon 3 30 × 40cm (11¾ × 15¾in)

Of these three studies, the first is closest to reality, while the remaining two show more abstracted approaches to representation.

I look upon the process of creating a series as a journey, an adventure that never fails to reveal new routes, beauty and excitement.

MY WORKING PROCESS

Some artists like to start out with a detailed plan of what they want to achieve and are in control of the painting throughout its creation. However, my approach is quite the opposite and is very process-driven.

I work very intuitively with no set goal in mind. Although I may have an idea of what I want to achieve, the piece can take on a personality of its own, which can prove to be very exciting, taking me in a completely different direction. Working in an intuitive way can be quite daunting, and you must be prepared to paint over areas you initially liked if the piece demands it, and to be ready to be led by the painting.

I begin this process with no preconceived end in sight but rely on a strong colour combination, a strong composition and a strong focal point. These three aspects become the starting blocks of an exciting and rewarding journey for me. Sure, obstacles are met along the way but I deal with these as they occur by using a bold, sometimes 'leap-of-faith' approach, which will hopefully elevate the piece to its finished glory.

My working process is very organic and will change according to mood, subject matter and the evolution of the painting itself. Any preconceived ideas will inevitably be challenged. (See pages 57–59, 'Observing the direction of the painting'.)

However, I do like to consider three important questions from the beginning:

1. **Concept or theme** – what is it that I want to portray? Will it be entirely abstract? A landscape, or a figure?
2. **Colour** – what colours have drawn me into this theme?
3. **Composition** – which composition will best convey this idea?

Often, I will pick three colours at random and go straight in to see what happens, concentrating solely on the focal point and composition, trusting my instinct and giving in to the urge to *play*. Sometimes the focal point will reveal itself to me later.

I like to 'break the rules' and push boundaries to see what works and which techniques work well together, asking myself questions – 'What if I did this?' – 'What would happen if I did that?' I am always experimenting and looking for new ideas.

I will often take old paintings that have just not worked or that display past, outmoded styles; I cut or tear them up for collage pieces. Alternatively, I will rework old paintings that have lost their lustre or reconsider experiments that didn't quite work. These pieces already have their layers built up and can be used as an underpainting that offers new potential. I lightly cover these old paintings with white gesso and see if I can find new shapes or compositions once the forms have been 'knocked back' – these will inevitably prompt me in a new direction. Some of these 'failures' have evolved to become some of my best paintings.

THE ORDER OF WORK

I gradually build up layers, taking cues from what has been previously laid down, adding collage and texture to areas, adding and subtracting components as the piece evolves – all to create interest so that glimpses of these underlayers can be seen in the finished painting. The process of layering, adding and subtracting gives the piece energy and a history.

Typically, I begin a painting by preparing the substrate using gesso, texture pastes or collage to give me a background on which to work. Other background techniques can be seen on pages 86–99.

I then begin to map out a loose composition with charcoal or other dry media, blurring the lines with gesso or water, as can be seen on pages 54–55.

Outlined on page 56 you will see that I have used different media to block in the main shapes and establish a more solid composition. Using various media will help me decide on which approach to take for the progression of the painting.

I then step back and observe in which direction the painting is going. Here, I make decisions about which areas need attention and development such as adding texture, collage, veiling certain areas and lifting paint in others. It's at this point that mark-making comes into its own in the form of creating design elements to produce a cohesive and meaningful piece.

Lastly, I decide on, and accentuate, the focal point, then add accents in dry media to make contrasts, adjustments and finishing touches to give the painting emphasis and impact.

These are just examples of my working process and are by no means 'set in stone'. That said, I hope that you will find this process both interesting and inspirational.

MAPPING OUT THE COMPOSITION

As you will have already seen, I like to use a variety of methods for mapping out my loose composition to start me off on the journey. By employing a similar approach, though utilizing different materials, you can obtain numerous results.

The reference photograph.

Shaping

The following three examples use the same reference photograph, shown above. The reference photograph shows a beach at Gurnard on the Isle of Wight, UK. I like the formation of the composition lines and shapes. You will note that I have outlined a loose composition in felt tip pen over the top, which gives me an abstracted starting point from which to work.

Once the loose composition has been drawn in, I will no longer refer to the photograph as the result will be an abstract piece.

CHARCOAL SHAPING WITH GESSO

I like to outline shapes and lines in soft charcoal and stabilize these with white gesso, as this gives a smudgy smokiness and ethereal quality from the beginning, putting me in the right mood. Although most of these lines will be covered, it helps me to immerse myself in the mystery, a sensation I wouldn't achieve by sketching with a pencil or diluted paint. See *Rock Strata*, pages 28–29.

COLOUR SHAPING USING INKTENSE PENCILS

You can also map out your loose composition with Inktense pencils, and activate them with a spray of water to release pigment. The pencil marks will form organic drips and runs to create interesting effects and subtle colour passages for your underpainting. See *The Meeting of the Waters*, pages 30–35.

COMBINING BOTH METHODS

Sketch in the composition using the charcoal stick and Inktense pencils side by side. Spritz with a water spray and see a totally different effect emerge. Notice how the water has reacted with the charcoal to form small bubble-like textures.

Blocking in the shapes

Using the examples from pages 54–55, I have used two approaches to blocking in the compositional shapes to produce ideas and concepts that will take the art further. Doing this helps me to explore different possibilities in creating an abstraction of shapes and also helps me experiment with various media to see which effects work best.

Here, two very different paintings are beginning to take shape, each one using the same reference photograph, and each taking on a journey of their own. In *Cottage on a Hillside*, opposite, you will see how I have developed the first of these into a finished painting.

USING ART BARS/WATER-SOLUBLE CRAYONS

Scribble on the colour and blend with a brush for a lighter wash colour or dip the crayons into water and apply directly. For a darker, more dramatic, effect, use the side of a damp crayon to scumble on texture. You can see here the versatility and fun element of these flexible crayons.

USING GOUACHE

Gouache will give you a more even texture as it blends beautifully. Use diluted with water for a wash effect or straight from the tube for bold colour. You can see some of the brush marks showing through where more water has been applied.

BLOCKING IN WITH COLLAGE

You can also use collage for a completely unique way to block in your colour shaping. Go for contrast and a variety of patterns as well as colour. Collage is explored in much greater detail in the following chapter (see pages 100–119).

OBSERVING THE DIRECTION OF THE PAINTING
Cottage on a Hillside

Referring to 'Blocking in the shapes', opposite, I selected the example that I created using art bars (water-soluble crayons). I decided to add some texture pastes and glazes to take it to the next level; I then had to make decisions about what to do next by observing the direction in which the painting was taking me.

In the following demonstration I show the observations and the decisions that I made based on these observations, in order to finish the piece.

Firstly I decided on the composition, using a viewing mat to seek out areas of interest. You can immediately see that an abstract landscape was beginning to form, which would give me a starting point from which to develop the piece, and the possibility of a focal point formed by the tree shape in the upper left.

To the right of the tree shape, I noticed the structure of a cottage emerging, which I accentuated with indigo acrylic paint using a flat brush.

I applied cadmium yellow acrylic paint with a sponge through a geometric patterned stencil to convey the impression of a brick wall, and to bring the foreground forwards.

I created some energetic marks in the middle ground with Indian ink applied through a pipette.

I dragged highlights in pink oil pastel over some of the textured parts of the painting.

Work in progress

I always take photographs of my work to review its progress; I check them in black and white to highlight tonal values, and look at them in front of a mirror to identify areas that require adjustment.

Other ways to observe possible directions are to turn the work on its side or upside-down, to see if there are any missed possibilities. You can also view your work through half-closed or squinted eyes.

Finally, I accentuated the focal point by adding a little white gesso with a palette knife to represent a window in the cottage.

Cottage on a Hillside 17 × 17cm (6¾ × 6¾in)

Although I originally intended the focal point in this painting to be the tree, as the original layout was cropped and the cottage emerged, it was obvious that this shape was the more dominant and therefore better placed (a third of the way in from the left) to become the focal point.

As I have outlined before, always be ready to change direction as the painting dictates.

MATERIALS AND TOOLS

Mixed-media painting can involve a number of exorbitant materials and tools, so I suggest that you experiment carefully with the supplies that you already have before investing large amounts of money in items that you may use only occasionally. It can also be a very overwhelming experience when you are new to mixed media if you have too many supplies to choose from.

If you are a more experienced artist, it is not my intention to describe the plethora of materials and tools here but to introduce you to some new products that may be unfamiliar to you and also to suggest ways in which they can be incorporated into your art. These are described further under the relevant sections.

Chrysalis 60 × 60cm (23⅝ × 23⅝in)

Mixed media on canvas.

This abstract painting depicting a butterfly emerging from its chrysalis employed the use of an array of tools and materials. I created texture with scrunched-up tissue paper, scrim (surgical gauze), resin sand and moulding (texture) paste spread through a stencil. Then I made further enhancements with stamps, squirted inks, spattered acrylic paint and oil pastels on an acrylic underpainting.

I applied the paint very loosely and energetically to create a feeling of spontaneity and movement. Although the main focus of the piece has a central, symmetrical cruciform composition, by placing the focal point outside the centre of the cross (the rounded square shape, upper left) and introducing the dark line, middle right, I have ensured that the viewer's eye moves around the painting.

I added further tension and interest by including some mark-making and texture techniques.

SURFACES, SUPPORTS AND SUBSTRATES

As well as using canvas (stretched or board) and watercolour paper for your creations, there are many other substrates and supports available to the mixed-media artist. Each has its own merits.

Left to right: mixed-media paper, watercolour paper, acrylic paper, primed birchwood panel, canvas sheet, canvas board, wooden board and Pastelmat paper.

Canvas

There are many choices of canvas on the market, from pre-stretched canvas, boards and sheets to canvas on a roll. I regularly use pre-stretched canvases in my work and canvas boards if I require a harder surface to work on. These boards have to be framed, or placed in a 'float' frame, once finished.

Pastelmat paper

A relatively new addition to the market, this paper was specially developed for pastel artists. Its unique velvety surface has the ability to trap and hold multiple layers of even the softest of pastels, without the need to apply fixative throughout the layers, as with conventional pastel paper.

Pastelmat paper is water-resistant and can be used for a variety of mixed-media work, either dry or wet. The painting, *Horse Power,* on page 7 was created on Pastelmat.

Watercolour paper

Watercolour paper is an ideal surface for mixed-media work. I always use a heavier weight of 300gsm (140lb) as it does not tend to buckle under heavy applications of paint and water. I also tend to turn and bend the paper to create runs and merges that would be difficult to achieve with lighter-weight paper that has to be stretched onto a board.

I use a smooth, Hot-pressed paper in my work as I find that rougher textured papers do not hold collage down as well. I coat my watercolour paper first with a layer of gesso to prevent the paint sinking into the surface.

Mixed-media and acrylic papers

These papers are usually sold in pads of various sizes but can also be bought in sheets. They tend to be of medium weight and with a slightly textured surface that can take both wet and dry media. Unlike watercolour paper, this paper is usually pre-primed so there is no need for a coat of gesso. I use these, and watercolour papers, for most of my framed works.

Papyrus

Papyrus is an organic material that was used in ancient times as a writing surface. It was made from the pith of the papyrus plant, *Cyperus papyrus*, a wetland sedge. I was lucky enough to purchase some of this fascinating paper while on holiday in Egypt and found it delightful to work on. Papyrus can be purchased on the internet but do exercise caution, as some products are synthetic and not organic papyrus. See *An Artist's Garden* (pages 87–93) for an example of creating a starch and water-soluble media background on papyrus.

Wood: birchwood cradled panels

Wood is a great support for paintings, especially for thick applications of paint and other techniques that require a rigid, sturdy support. Birchwood makes a good thin, lightweight panel for larger paintings. Make sure that the surface is primed with gesso first to reduce any natural impurities or resins that might affect the paint layers.

The cradled panels can stand proud on a wall without the need for framing or can be inserted into a float frame for a more professional finish.

MEDIUMS AND ADHESIVES

Mediums

When I started out on my mixed-media journey, I was so fascinated by all the mediums available, and ended up purchasing many, only to find that most of these I really didn't need and over the years they dried up. Nowadays, I try to keep the mediums I use to a minimum, keeping only the ones that enhance and give meaning to my work.

Mediums and adhesives

1. PVA glue
2. Marble effect spray
3. White gesso primer
4. Talcum powder
5. Gesso, talcum powder and PVA mix
6. Photograph mount spray
7. 'YES!' paste
8. Sand texture gel
9. Matt medium
10. Glass bead texture gel
11. Gloss medium
12. Matt gel
13. Fibre paste
14. Soft gel (gloss)
15. Glue stick
16. Clear gesso
17. Gel paste
18. Gloss gel

TEXTURE PASTES

I use these often to produce texture and interest. Moulding paste or texture paste is perfect for spreading through stencils and creating form; it comes in various weights – light, medium and heavy. It is also good for use in assemblage to create a firm, adherent base on which to embed heavy or awkwardly-shaped objects (see page 119, *Treasures of the Tide*). These pastes are not transparent and will dry white but can be pre-mixed with acrylic colour or painted over with other materials once dry.

GEL PASTES/MEDIUMS

These are colourless acrylics that can be used to create texture or mixed with acrylic paint to alter their consistency and drying time. They come in a variety of weights from runny to firm, giving you options as to their use. They can also be used as a glazing medium.

Gel pastes can be used through stencils to give texture and will dry transparent (see page 77, *Lobster Pots*, in which I have used the gel paste on the harbour walls).

Other products I use are textured granulated products, such as resin sand, glass bead gel and blended fibre gel, described below; however, there are many more on the market.

Note: All the mediums listed below are water-based.

Sand texture gel This is a lovely, gritty, sandy texture that I regularly use. You can find examples of this texture gel in many of the paintings in this book. I particularly like to use it to represent the roughness of a harbour wall, buildings or foregrounds, rocky terrains and sandy beaches.

Glass bead gel Tiny glass particles are trapped in a transparent gel to give a gentle, almost ethereal, texture. I use a thin application of this gel to create interest in flower centres, to give the impression of seeds (see *Pollen for the Bees*, pages 46–47).

Blended fibre gel Finely shredded fibres are integrated in this gel, which gives an interesting but understated texture with a matte sheen that I use for subtle foregrounds, particularly in my abstract landscapes (see *Moonrise across the Field*, page 78).

Glazing medium I use this medium with my acrylic paints to increase their transparency for use as glazes (see pages 130–133 for examples). It also serves to thin out acrylic paint, maintain colour vibrancy and to extend the fast-drying times of acrylics.

Matt medium This is my first choice when it comes to thinning out paint, sticking down collage and creating a polymer surface, to protect the more delicate collage papers. It dries clear and is extremely versatile.

Gloss medium This equally versatile multi-purpose medium can be used as a final gloss varnish over a finished piece; I also mix it with paint to stain white tissue paper for use in collage, and use it instead of matt medium if I want to achieve a gloss finish.

Gesso Where would I be without gesso? It's not just an acrylic primer for preparing canvases and other substrates; I also use it often in my veiling techniques to create texture and mystery (see pages 122–125 for examples). It can also be used as a resist. In addition, I use clear gesso as a base for pastels as its attributes are many. Gesso can be purchased in white, black, coloured or clear. It can also be mixed with PVA glue and talcum power to create a thicker textured paste (see page 75).

Adhesives

As well as using matt medium as an adhesive, I find the following glues useful in collage work:

PVA glue I'm sure you are all too familiar with polyvinyl acetate from your school days. It is non-toxic, dries clear and has good adherence properties. I use it in place of matt medium to glue down thicker collage papers and also to create texture by pouring diluted glue in runs on which to add paint once dry.

'YES!' paste Popular in the US, this paste has excellent adherence properties and I use it to stick down large pieces of collage paper as it does not make the paper buckle. It's also good for attaching paintings on paper onto wood panels to eliminate the need for framing or to show off in a float frame. The paste is extremely sticky so care must be taken not to brush the paste over the upper surfaces of collage papers.

Glue stick I use these handy glue sticks to lightly paste down words, phrases or numbers in a scrapbook so that I can find and remove them easily for use in my collage work.

Photograph mount spray I use this light spray to attach tissue paper to a carrier paper when printing imagery (see page 121 for details on this technique).

GENERAL TOOLS

I have a cupboard full of general tools that I use in my mixed-media work and am always finding new ones to add to my collection. I've listed some of my favourites but you probably already have some of your own favourites too.

General tools
1. Wet wipes
2. Masking tape
3. Sander
4. Cellophane and plastic food wrap
5. Kitchen paper
6. Ruler
7. Assorted palettes (tear-off paper palette, plastic food container lids, ice-cube tray)
8. Pipettes
9. Brayers
10. Scissors
11. Latex/plastic gloves
12. Spray starch
13. Old credit card
14. Assorted brushes
15. Scraper
16. Squeegee
17. Palette knives
18. Blending tools/tortillons
19. Natural sponge
20. Cotton buds (cotton swabs)
21. Assorted manufactured sponges
22. Spray bottle of isopropyl alcohol
23. Spray bottle of water
24. Sanding block and paper

Kitchen paper towels and wet wipes These are used to spread paint around, to clear up unwanted paint and to create texture.

Latex or rubber gloves These can be worn as protection against any dyes present in inks or paints for messier applications, and for blending these when using your hands.

Masking tape This is ideal for taping down paper, masking off areas or to give a white framed edge.

Spray starch Spray starch can be used to dilute paint and form interesting backgrounds (see pages 86–93).

Water-spray bottle Spray water onto paint in order to dilute the pigment and move the paint around.

Pipettes These can be used to squirt liquid inks onto a substrate.

Isopropyl alcohol This liquid will lift acrylic paint off the surface once dried, and can be used to create organic effects in wet paint.

Plastic food wrap This can be used to create patterns and texture in wet paint, if scrunched or pleated.

Cellophane Lay a sheet of cellophane over wet media and manipulate the media beneath to create exciting backgrounds.

Sanding paper or block These can be used to sand down any rough textured edges, or to sand back collage elements to reveal the layers beneath.

Small electrical sander I find this tool invaluable for distressing collage elements to produce a grungy, multi-layered effect. I sometimes use sanding blocks (above) but they don't do the job as well as the small electric sander when distressing thicker layers of collage.

Applicators I like to use a variety of applicators in my work, including brushes, palette knives, old credit cards, squeegees, cosmetic sponges, natural sponges, cotton buds (cotton swabs) and brayers.

Palettes These range from specialist acrylic tear-off paper palettes and freezer paper to Perspex and ice cube trays for mixing wet media such as inks and glazes.

DRY MEDIA

I tend to use dry media either to outline compositions at the beginning of a painting or in my mark-making techniques at the end. Besides the dry media we are all familiar with, such as coloured pencils, watercolour pencils, pastel pencils, graphite, charcoal, felt-tip pens, ink and gel pens, here are some others that I use on a regular basis.

Dry media

1. Wax pastels
2. Pan pastels
3. Felt-tip pens and brush pens
4. Mechanical pencil
5. Inktense pencils
6. Coloured pencils
7. Pastel pencils
8. Art bars
9. Graphite pencils
10. Charcoal sticks
11. Charcoal pencils
12. Soft pastels
13. Brusho in pots
14. Putty eraser
15. Oil pastels

Inktense pencils

These wonderful, versatile pencils create inky colours and effects when combined with water. Although they are water-soluble, they become stable once dry and can be worked over without affecting any underlayers. They also can be bought in blocks.

Brusho

Brusho consists of fine, powdered watercolour crystals that are highly pigmented, creating beautiful explosions of colour once activated with water. A little goes a long way and the results can be extremely random, or more controlled if used with a brush like watercolour paint.

Pan pastels

Besides using oil pastels, and soft and hard pastels, I also adore the creaminess of a relatively new product – pan pastels. These gorgeous colours come packaged as 'cakes' so they can be applied like paint with a cosmetic sponge, brush or shaping tool. They generate very little dust and contain a minimum of binders and fillers, so are very user-friendly. Pan pastels are great for applying through stencils.

Art bars

I've started to use these solid pigment sticks for blocking in bold colour, then activating them with water to give a rich, opaque coverage of colour. Art bars are also useful for line and wash effects and mark-making.

Pastel spray fixative

Pastel spray fixative stabilizes pastel or charcoal so that you can continue to paint around it; it can also prevent some of the dust from rubbing off when you handle the painting. The only downside of this spray is that it will dull the colour once dry.

There are different pastel fixatives available, from a workable fixative to the final layer fixative. Working on Pastelmat paper will eliminate the need for fixing between layers, but a final coat of fixative will still be necessary.

Don't be tempted to use hairspray as a fixative – hairspray is fine for studies but it is non-archival and contains an oil that could cause damage to other materials.

WET MEDIA

In the past, wet media was limited to the conventional watercolours, gouache, oils and inks. However, the arrival of alternatives, such as acrylic paints and inks, spray paints, Brusho pigments, water-soluble pigment sticks (art bars – seen on the previous page) and brush pens, has given painting new and exciting possibilities especially within the realm of mixed media.

I suggest that you always use good-quality artists' paints and materials, which have a high pigment content and good coverage capabilities, as opposed to student-grade materials. On the following pages are some of the products that you will see me use in my work.

Paints

ACRYLIC PAINTS

You will doubtless be familiar with acrylic paints, which have eliminated the need for solvents and other such chemical dilutants. They are versatile, vibrant, easy to use, and have a fast drying time, meaning that layers can be built up quickly. There are no rules about painting 'fat over lean' or light to dark.

Acrylics also mix beautifully with other media and provide a firm base on which to build up texture and add layering, glazing, collage and bold mark-making. As well as using traditional acrylic paints in my work, I also use fluid acrylics and Open acrylics – see opposite.

Wet media

1. Acrylic paints
2. Spray paints
3. Indian ink
4. Liquid watercolour inks
5. CitraSolv
6. Watercolour pans
7. Fluid acrylics
8. Oil paints
9. Gouache
10. Brush pens
11. Open acrylics
12. Household emulsion
13. Acrylic inks

FLUID ACRYLICS

These paints are of a thinner consistency than standard acrylic paints but have a very rich pigment content and provide wonderful glazing possibilities (see pages 130–133). They can also be applied undiluted in thinner layers, giving a vibrant richness and depth of tone. Because of their levelling properties, any brush marks are practically eliminated.

You can make your own fluid acrylics by diluting ordinary acrylic paint with water or matt medium and keeping this in a tightly-sealed jar or pot. I do this often if I have too much paint left over on my palette.

OPEN ACRYLICS

These have a slower or extended drying time for methods that require more manipulation of the paint, better blending capabilities and other techniques that you would normally use with oils. I use these paints on my gelli plate (see page 102) to give me extra time in which to create patterns through monoprinting or mark-making.

GOUACHE

I rarely use watercolour paint in my work but have started to use gouache, particularly for creating underpaintings in my pastel work. It can be reactivated with water to achieve different effects and can be used without adhering to the rules of working light over dark.

Inks

INDIAN INK

I love the bold quality of black Indian ink and its ability to give beautiful tonal shades of grey when combined with water. It is permanent when dry, and I particularly enjoy using it in my mark-making by squirting it onto the substrate with a pipette.

LIQUID WATERCOLOUR INKS

These are beautiful, transparent, vibrant colours, which can be used as a glaze on top of acrylics or to portray subtle colour nuances in specific areas. I use these over my starch backgrounds. If these inks are used, please note that they are not a stable material and can be reactivated with water so care must be taken. Framing under glass is essential.

ACRYLIC INKS

There are many acrylic inks on the market today and they are great fun to play with. They have highly-saturated pigments and create rich glazes; they can be mixed with water to produce large areas of colour, or squirted or drawn with by using a pipette in mark-making. Unlike watercolour inks, acrylic inks dry permanent and can be worked over easily.

Other

BRUSH PENS

Relatively new on the market, these pens are great for sketching, experimenting and adding accents on a final layer. They can also be easily blended with one another to create glazes and layering.

SPRAY PAINTS

In the past I've encountered a bit of trial and error with acrylic spray paints, as I initially found that the nozzles were continually becoming blocked, which led to frustration and wastage. I now use the solvent sprays that graffiti artists use, which work perfectly through stencils and act as a resist when layering. Be sure to wear a mask when using these products.

CITRASOLV

This product is a household degreaser that is used in the art world for altering the appearance of certain pages of old *National Geographic* magazines (see page 103 for more information). These pages comprise a highly pigmented ink on clay-coated paper, which react beautifully to CitraSolv.

Right: National Geographic *paper treated with* CitraSolv.

Mixing the media

MIXING THE MEDIA

Throughout the preceding chapters, we have looked closely at what makes a piece of art abstract, in terms of colour choices, composition decisions, design and interpretation. We now come to the point where we investigate the exciting possibilities of mixed media.

We will start by creating various backgrounds on which to build, moving on to ways of mapping out the composition, use of collage and textures, and adding transparency and more mark-making onto dry and wet media.

Above the Mist 25.5 × 35.5cm (10 × 14in)
Mixed media on canvas.

This mixed-media piece was inspired by a popular climbing venue close to my home. I prepared the canvas with a coat of thick gesso and adhered crumpled tissue paper to give the first layer of texture. I then sculpted the form using acrylic paint, gouache and resin sand. I printed out some text describing the scene onto tissue paper, changing the original typeface to an old typewriter font, and added this to the top-left sky area, veiling over with a thin coat of gesso. To finish, I dragged orange oil pastel over the resin sand and used a stencil to create accents with turquoise acrylic paint.

CREATING BACKGROUNDS

An important part of the painting process is to decide on a background and support on which to paint. We're all too aware of the anxiety that can be caused by a white space, which can block our intuitive freedom to create, so I've experimented with various ways to produce an interesting background that will form a pathway to the evolution of the work.

These are just some of the techniques that I use.

PREPARING THE SUBSTRATE

Instead of using brushes to apply your base paint, paint or gesso can be spread easily over the substrate using plastic cards, brayers and other spreaders. These can be quicker and smoother than using a brush, or can be applied roughly to create some initial texture.

Experiment with different kinds of paint spreaders to see the unique effects each tool produces as shown in the examples on the right and below.

Left to right: Dry brush, wet brush, plastic card.

Left to right: Palette knife, natural sponge, cosmetic sponge.

Left to right: Wet paper towel, squeegee, brayer.

CREATING A HEAVILY-TEXTURED BACKGROUND

Creating background texture using gesso

Gesso can be applied to the substrate in varying thicknesses, and moulded or manipulated with a palette knife or such other applicator. PVA glue and talcum powder can also be added to gesso to create a rich textured paste (see right). The beauty of this technique is that you will have control over its consistency. The thickness of your gesso will dictate how much talcum powder and PVA to use; experiment, and when you have reached your desired consistency, spread the paste onto your chosen substrate.

Further texture can be made by blotting the gesso mix with paper, plastic food wrap or cellophane to create ridges (see *New Directions*, pages 80–85); alternatively, lines can be incised in the mix for added interest.

Mixing gesso, talcum powder and PVA glue.

You can see in this example the two different textures created by blotting the gesso paste with cellophane for a mottled look and applying pressure with a palette knife to form ridges.

Creating background texture with pastes and gels

There are many commercial texture pastes and gels on the market today, which can be overwhelming and lead to confusion. The commercial products that I personally use are moulding or texture pastes of various weights, resin sand and other texture gels, as I've outlined in 'Mediums and adhesives' (see pages 64–65). I recommend that you try other ways to create texture – such as adding sand, grit or sawdust to PVA glue – before you splash out on expensive commodities.

Texture pastes can also be applied by spreading through a stencil; they can be sculpted, moulded and drawn into with bamboo skewers or the end of a paintbrush. Marks can be made into the pastes by pressing in objects from your mark-making stash, as shown below.

Upper left: Glass bead gel applied and spread around with the back of a teaspoon.

Upper right: Texture paste applied through a stencil.

Middle: Fibre gel applied smoothly and roughly to form ridges.

Lower left: Resin sand, smooth and rough.

Lower right: Gesso, talcum powder and PVA mix applied with a palette knife, smooth and textured.

Above: Glass bead gel being applied to the demonstration, Pollen for the Bees, *pages 46–47*

In the examples below and on the opposite page, I used a palette knife to apply medium-texture paste to a substrate. I then impressed various items into the soft paste to give interesting effects. I removed these before the paste was dry, then applied colour over the top.

Besides using commercial products to create texture, I also use scrunched-up pattern paper, corrugated card, scrim (surgical gauze) and netting.

A bottle protector was pressed into and pulled out of the wet paste.

A hair comb was dragged across the wet paste.

Using the edges of a credit card, I made slashes into the wet paste.

Lobster Pots 40 × 30cm (15¾ × 11¾in)

Using primed watercolour paper as my substrate, I created texture using gel medium applied through a stencil, and scumbled over this with oil pastel to represent the harbour walls. I adhered scrim and corrugated card to create the texture of the lobster pots, giving the whole piece a naïve, simplistic yet quirky feel.

Here, a hair roller was rolled across the paste.

A toy building brick was used to stamp into the paste.

A piece of plastic needlework mesh was pressed into and pulled out of the wet paste.

Below are two examples of finished paintings from the same series depicting the theme of a moonrise, using texture pastes and gels.

Note
Avoid using brushes when applying texture pastes as any residue from the brush will be difficult to remove from the surface.

Moonrise across the Field 30 × 30cm (11¾ × 11¾in)
Scrim, or surgical gauze, has been adhered to provide texture in the sky, and blended fibre gel applied with a palette knife across the landscape. You can see at a glance how the paint has picked up these atmospheric textures.

Autumn Moon 30 × 30cm (11¾ × 11¾in)
I applied heavy gel in some areas with a palette knife; while the gel was still wet, I pressed in textures and scraped away parts with a plastic card to produce grainy effects.

OPAQUE VERSUS TRANSPARENT PASTES

Opaque pastes can be painted over once dry, whereas transparent pastes pick up the colour of the paint beneath to give a more gentle and translucent quality. These opaque pastes can also be mixed directly with acrylic paint to give them more body and thickness. A lighter, subtler texture can be achieved by blotting the tacky paste with paper and peeling it off; a smoother effect can be achieved by burnishing over the paper before carefully peeling off the paste. Light brushstrokes just touched over the top will give a delicate finish. It all depends on the narrative you wish to convey.

NEW DIRECTIONS

In this demonstration, I will be applying a heavily-textured background to a stretched canvas. Although this is a landscape painting, I will be using the canvas in a portrait format and working intuitively without any reference photograph – simply relying on contours, shaping, composition and colour to create an abstraction or essence of a fictitious landscape.

Please do not feel that you have to follow my process to the letter; be guided by the mood of your own painting and its sense of place.

MATERIALS AND TOOLS

Surface: Stretched canvas, 41 × 51cm (16⅛ × 20in).

Materials: Texture pastes (I have used the PVA glue–gesso–talcum powder mix, and resin sand); acrylic paints in turquoise, indigo, cadmium red and yellow ochre; acrylic inks in turquoise; red oil pastel; black charcoal; small mixture of collage papers (I have used oriental fibre paper, CitraSolv papers and dressmakers' buff pattern paper); matt medium or other adhesive; collage text and spray fixative.

Tools: Tear-off paper palette; palette knife, plastic card or similar spreading tool; mark-making tools (bottle tops, hair roller); brushes of various sizes; kitchen paper and damp rag.

1 Thinking in terms of a composition of either the Golden Section (Rule of Thirds) or a tunnel structure, I started to apply texture pastes with my palette knife. Here, I applied the PVA glue–gesso–talcum powder mixture across the bottom-left two-thirds and resin sand on the bottom-right and upper-right thirds; the upper-left was kept plain. These textures were applied in both a traditional sweeping of the knife and a choppy 'stamp-on-lift-off' method.

2 I then embedded a bottle top into the wet paste on the bottom-left and scraped through the texture on the right with a hair roller.

3 Once the texture pastes were thoroughly dry, I laid on my chosen colours – turquoise, indigo, cadmium red and yellow ochre – straight from the tubes, in a random fashion.

4 I spread the colours around using a plastic card and then a brush, all the time thinking of the structure and composition of the painting.

5 I added some more paint as required – in this case I added red. I spritzed the paint with water, then, using a brush, pushed this paint into the nooks and crannies of the textured surface.

6 I made additional marks by roughly inscribing into the wet paint with the end of the brush. Some of the colours seemed a little muddy but I would cover these areas with pure colour as the painting progressed.

7 I added a little collage to create underlying layers to the lower half on the canvas (though trying not to cover the main textured areas). I tried out the placement of these collage elements prior to adhering them so I could make considered compositional choices.

8 I selected some CitraSolv collage papers to represent a rock formation, as their patterns were perfect – I secured these to the substrate using matt medium.

9 I then encapsulated these papers more fully into the scene by dabbing a thin application of paint over them with a damp rag.

10 I smoothed out any wrinkles in the collage papers with a plastic card.

11 I roughly tore up some pieces of dressmakers' pattern paper to create even more texture.

12 These papers were adhered by brushing matt medium over the top and making wrinkles and creases to enhance the look of the rocks.

13 I began to create form with colour; I brushed on indigo straight from the tube into the upper-left, and with a dry brush scumbled some indigo into the middle areas to produce some perspective. While the paint was still wet, I applied some more indigo paint to the upper left, spritzed it with water droplets and blotted these off with a sheet of kitchen paper to form organic patterns.

14 I mixed together yellow ochre and white to give a light contrasting colour, and began to outline some form to resemble rocks in the bottom half of the painting, using a flat brush.

15 I created marks in the paint with the end of the brush.

16 I spritzed the upper-right of the canvas and applied a coat of white gesso with another sheet of kitchen paper to give a veiling effect.

17 I painted in some turquoise acrylic paint, and blotted this off with kitchen paper while it was still wet, to build areas of broken colour.

18 I added a glaze of turquoise acrylic ink to the dark area in the upper left to enhance its pattern.

19 At this stage, I checked my progress and took photographs to ensure I had enough tonal variety – now was the time to make adjustments. For instance, I could see that the dark form in the middle of the painting resembled a far-off mountain, so I used this to the advantage of the design by accentuating the line of the rock face on the left with more turquoise acrylic ink applied with the pipette of the ink bottle.

20 I spritzed the ink gently with water and lifted the canvas to enable the ink to run down and through all the underlying textures.

23 I scumbled red oil pastel over the textures, making a directional focal point through the painting for the viewer's eye to follow.

24 As it felt right to do so, I added some collaged words to describe the atmosphere of the scene and give a hint of a narrative to the viewer – here, I adhered the words 'New directions'. I sealed the words to the surface with matt medium.

25 Finally, I added a few details in black charcoal to accentuate the areas over the tops of the rocks and sealed everything with a spray of fixative.

New Directions 41 × 51cm (16⅛ × 20⅛in)

NEW DIRECTIONS

STARCH AND WATER-SOLUBLE MEDIA BACKGROUND

Using starch as an alternative to water gives a thicker, more substantial base on which to manipulate paint. It can also help to fix some of the more unstable paints, such as watercolour inks or Brusho.

Using primed watercolour paper or mixed-media paper, spray the area with a thin layer of spray starch. Drop or flick on a selection of water-based media such as Brusho, acrylic and watercolour inks, and fluid acrylics. Spray over the top with more starch and cover with a sheet of polythene or a clear plastic bag. Move the paint around under the polythene with your hands, and leave to dry. The starch will react differently with each type of paint, creating interesting textures and effects. Many of these organic shapes will provide you with immediate inspiration; those that don't can still provide you with some amazing fodder for collage. I use this method for backgrounds, mainly for floral and abstract figurative work, but I have also successfully used it to create landscapes and seascapes. An example of using this background technique using all four of the products on papyrus can be seen in the following demonstration, *An Artist's Garden*.

Warning
This technique can be quite addictive. It can also get very messy, so protect your work surface.

Effects of using acrylic inks on a spray starch background.

Effects of using Brusho on a spray starch background.

Effects of using watercolour inks on a spray starch background.

Effects of using fluid acrylic paints on a spray-starch background.

AN ARTIST'S GARDEN

In this demonstration, I use various water-soluble media to create an abstract floral portrait using the spray-starch background technique on papyrus paper. This technique will work on any other artists' paper if you do not have papyrus.

I love the fragility and the uncertainty that this method conveys; it is perfectly suited to floral pieces, although I do use it with other subject matter.

The initial process can get very messy, so it's advisable to protect your workspace and your hands with gloves, as some of the paints contain dyes that can stain your skin.

MATERIALS AND TOOLS

Surface: Papyrus paper, 32 × 42cm (12½ × 16½in).

Materials: Matt medium; spray starch; liquid watercolour inks in China blue, light yellow and carmine; acrylic inks in vivid red orange, process yellow and quinacridone magenta; fluid acrylics in teal, manganese blue hue, phthalo green yellow and Hansa yellow light; Brusho in rose red, sunburst lemon and Prussian blue; acrylic paint in titanium white; white charcoal or pastel; white gesso; collage papers and text; stained tissue papers and hand-decorated papers.

Tools: Masking tape; board or firm surface; sheet of polythene; assorted paintbrushes including a medium flat brush; kitchen paper; pipettes; stamps and stencils; viewing mat or viewfinder and cosmetic sponge.

1 I prepared the papyrus paper by coating both sides in matt medium using a flat brush, to prepare a base for the paint and to stop any leakage through the papyrus fibres. Once it was dry, I taped it down onto my board.

2 I sprayed the papyrus lightly with starch.

3 Next, I dropped in my choices of medium in a random fashion: acrylic inks (applied with their stopper), liquid watercolour inks (applied with a pipette), fluid acrylics (straight from the bottle) and Brusho (sprinkled on with a palette knife) were used here.

Applying powdered Brusho with a palette knife.

4 I sprayed the papyrus with more starch, and laid a sheet of polythene over the whole piece. The paint could then be manipulated under the polythene by hand. I allowed the piece to dry thoroughly overnight.

5 I removed the polythene to reveal the beautiful, abstract background on which I could develop the painting.

At this stage, look closely at the patterns that have formed: you may be able to see different compositional choices or different forms appearing. I could immediately see the shape of a vase and flowers spilling across the paper.

A change in aspect

Although I originally intended for this to be a landscape-format painting, once I removed the polythene, I saw the shape of a green vase. This prompted me to change the piece to a portrait format, with the green vase at the bottom, anchoring the flowers.

6 I mapped out the composition using a soft white pastel.

7 Next, I veiled in the negative spaces around the flowers and vase with white gesso applied with a sheet of damp kitchen paper, ensuring that some of the muted colours would still show through.

8 Using a viewing mat to establish composition, I drew around my selected compositional area with white soft pastel to indicate which areas required more development.

9 I began to apply torn collage pieces to heighten the colour harmonies. Stained tissue paper proved ideal for this purpose as it allowed the underlying colours to show through. I decided on the flower that would become the focal point, and enhanced its shape with torn orange tissue paper.

11 I made more marks by squirting a green ink in places – using its pipette stopper – to resemble foliage and create energy.

10 I highlighted this main flower further by drawing in its outline using acrylic ink applied through the stopper.

12 I then established more flower shapes using a flat brush to stamp on layers of paint.

13 I added to the collage with torn, hand-decorated papers to build up the floral theme.

14 Once again, I veiled the negative spaces around my outlined compositional area of the vase, this time with white acrylic paint, to help it stand out from the rest of the painting.

15 To develop the floral shapes more, I chose some organic stencils that would give the flowers definition. You will note that I made the decision to change the original main orange flower to pink by painting though a stencil, as I felt that this fitted in better with the design.

16 I applied paint through the stencil with a cosmetic sponge in certain areas.

17 I then did the same with an organic designed stamp, stamping on areas to define form and pattern with red paint.

18 I sprinkled red Brusho with a palette knife into other areas...

19 ...and spritzed the Brusho with water to disperse the pigment.

20 I began to finalize the painting by using the end of a pencil as a stamp to create the flower centres.

21 Looking through my stash of collage words and text to give the piece meaning – and maybe a title – the text 'An artist's garden' worked perfectly, and this was adhered to the bottom right overlapping the vase.

22 I made my last little touches by stamping more white marks with the end of a pencil to bring the whole design together.

An Artist's Garden 32 × 42cm (12½ × 16½in)

Waste paint palette paper as a background

I always have spare pieces of paper by my side to wipe off any paint that I have left over on my brush, applicator or palette. I build up layers of these leftover colours to use as collage or as a new painting. See *Watermelon Woman* on pages 122–125 for an example of how veiling can transform these random colour explosions.

Swatches of waste paint on the palette and on paper.

Squeegee drag background

Apply lines of different coloured paint across sections of your substrate, then with a squeegee or windscreen wiper, drag the paint downwards, mixing some of the colours as you drag. If your paint application is thick, spray it lightly with water before dragging. Any extra paint left on the squeegee can be used on your waste paint paper palette (see above).

Try dragging the paint in different directions for a variety of effects, as shown below, right. The example on the left is a downward drag, while the example on the right shows the paint having been dragged across the substrate. The middle example is a mix of the two methods.

Interesting intersections of the colour will appear; these can be as controlled or as spontaneous as you like. I particularly like the broken colour effect of the first example.

Application of this style of background can be seen in the following demonstration, A Different Perspective.

A DIFFERENT PERSPECTIVE

In this demonstration, I have created an abstract background reminiscent of a city skyline using the squeegee method on primed birchwood cradled panel; however, any substrate you choose would be fine. I have chosen vibrant colours to represent the hustle and bustle of city life, and set it on a diagonal format for more drama.

The birchwood panel used as the substrate for this project.

MATERIALS AND TOOLS

Surface: Birchwood panel or substrate of your choice, 30 × 30cm (11¾ × 11¾in).

Materials: Acrylic paints in primary yellow, orange-red, ultramarine blue, cerulean; white gesso; various collage papers reminiscent of building and linear forms; matt medium and black Indian ink.

Tools: Squeegee; flat paintbrush; old toothbrush; cosmetic sponge; stamps and stencils representing the geometric and linear forms seen in a city.

1 I primed the board with white gesso, then laid bands of acrylic colour on a diagonal across the surface.

2 Using a squeegee, I lightly dragged the colour across the surface to create forms of tall buildings and establish a water line.

3 I then dragged the wet paint in the other direction to enhance the shapes of the buildings and reflections in the water.

4 I cut out rectangles, strips and circles of collage material to represent a cityscape or series of tall buildings, all of which matched the primary colour scheme.

> ### Building a city in collage
> *Take your time in selecting collage patterns and papers that reflect the feel of a cityscape, such as linear patterns and blocks, theatre adverts and other such promotional material – it all adds to the atmosphere of a bustling city. Do the same when selecting stamps and stencils for such a project.*

5 Using matt medium, I began to adhere these rectangles of collage to create the skyline, and added circles for contrast in other places. I used a larger circle to establish a clear focal point, and added a long rectangular piece of collage across the piece to re-establish the water line.

6 I painted reflections in the water by pulling down red and blue paint with a flat brush.

7 I then stamped in more reflections using yellow paint on a piece of corrugated card.

8 Marks were made by stamping with commercial stamps, toy building bricks and other items coated with Indian ink, which enhanced the scene.

9 I applied the yellow paint to sequin waste with a cosmetic sponge and stencilled in the reflections in the water.

10 I accentuated the focal point further by stamping around the yellow circle with a bottle top coated in Indian ink.

11 Finally, I added a little sparkle with some white paint spatter, applied with a toothbrush – I covered the areas I didn't want to spatter with a sheet of kitchen paper.

A Different Perspective 30 × 30cm (11¾ × 11¾in)

COLLAGE

I use collage consistently when I am creating as it gives yet another dimension to the mystery of the art and is almost mandatory for use with mixed media.

From beautifully patterned and tactile papers to sneaky glimpses of text that gives a hint as to the formation of the piece, collage papers can include – but are not limited to – exotic rice papers, newsprint, magazine papers, tissue paper, wrapping paper, bought papers and *National Geographic* magazine papers.

COLLAGE COMPONENTS

Text and numbers can frequently be seen in my collages: I think that they help to convey meaning and interest. Some of these will be partly obscured but glimpses will still show seductively through the layers.

In order to have these details readily available I glue them lightly into a scrapbook with a glue stick so that I can see at a glance words and passages that could be used in a painting. Most of these collage elements come from magazines, tourist brochures, newspapers or even junk mail.

Other possible collage elements include playing cards, tickets, maps, postage stamps, all manner of ephemera, card, doilies and so on. Bulkier items can also be used as collage and are often referred to as assemblage. These can include scrim (surgical gauze), vegetable netting, old coins, crushed egg shells, dried leaves and grasses, pressed flowers, broken crockery and countless other natural or manmade found items.

Below: Various text and phrases cut from magazines and other sources, adhered lightly with glue stick into a scrapbook; numbers cut from various sources adhered lightly with glue stick into a scrapbook.

A collection of collage papers including patterned and tactile decoupage papers, and printed papers such as newspaper, manuscript paper and dressmakers' pattern paper.

A selection of collage elements including stamps, playing cards, lace doilies and tickets.

Assemblage
Larger, bulkier collage components, including corrugated card, pebbles and stones, scrim (surgical gauze) and netting.

CREATING YOUR OWN COLLAGE PAPERS

I can spend a whole day creating papers for collage – sometimes it's as simple as doodling with different tools, making meaningless marks, creating illegible handwriting (see page 157) or casual mark-making, as with the graffiti papers on page 106. However, one of my passions is to create patterned papers using a gelli plate.

Using a gelli plate

The gelli plate is a clear, flexible, jelly-like silicone surface in the form of a slab, and comes in various sizes. I adore using my gelli plate not only to create papers for collage but also to produce monoprints and paintings in their own right (see 'Printmaking methods', pages 138–143).

Any kind of paper can be used on the gelli plate, from simple printer paper to a transparent deli paper (see page 138). Most printer inks or acrylic paints create good prints on the gelli plate, but if it is your intention to make more complex designs then I suggest that you use Open acrylic paints, which will extend the drying time and allow you to develop the prints at a slower pace.

When starting out with gelli-plate printing, please note that you do not require a great amount of paint – too much paint will produce blurred prints with little detail. Practice and experimentation will soon reveal the correct amount to use.

A range of papers that can be used with a gelli plate, including parchment paper, rice paper, thin card and Japanese card.

1 Apply flat colour to the surface of the plate.

2 Roll the paint over the plate with a brayer in a thin, even layer.

3 Place a sheet of paper (I used printer paper here) over the paint and burnish down with your hand. Pull the paper off the plate to reveal the first layer ready for additional layers of pattern. See pages 139–141.

A variety of papers has been used here, including packing paper, brown paper, oriental paper, printer paper, stained tissue paper and deli paper (see page 138). You could also use newsprint, magazine pages, music sheets and so on.

CitraSolv papers

CitraSolv papers are created using an interesting new technique that involves sprinkling a natural household degreaser, CitraSolv, onto pages of a *National Geographic* magazine, closing the magazine and leaving it for a few hours or overnight. During this time, the CitraSolv dissolves the printing inks and produces beautiful, random, organic patterns. CitraSolv also has the advantage of smelling delightful (think freshly-peeled oranges) and there are no issues of copyright in using the papers in your artwork, as the appearance of any photographs is changed beyond all recognition.

It's a good idea to apply a coat of UV varnish to any finished work: because this is a relatively new technique, its archival qualities are unknown. There are numerous online videos available on the subject – I urge you to take a look at these as they will give more detail on which pages of the magazine to use, the amount of CitraSolv required, and information on drying times. You can also discover some of the art and other artists using this technique on www.citrasolv.com

You can see examples of the application of these collage papers on pages 158–159 where they form the standing stones of The Pagan.

STENCILLING ONTO CITRASOLV PAPERS

Lay your chosen stencil onto the CitraSolv paper and secure it with tape. Wet some kitchen paper or rag with CitraSolv and rub it into the spaces on the stencil. Any small spaces in the stencil can be rubbed over with a cotton bud dipped into the liquid. The ink will easily lift off and give a unique pattern or image.

Rubbing CitraSolv through a stencil onto CitraSolv paper.

Peeling off the stencil to reveal the transferred pattern.

Hand-decorated papers

Decorating your own papers can be fun and give surprising effects – see page 107 where I have used some of these decorated papers to form a coloured collage background. Use any paper you like; I particularly like to use deli paper (see page 138) for its transparent effect, but other papers work well too, such as packing paper, printer paper, scrapbook paper and rice papers.

Spray paint applied through a stencil with other stamped marks on printer paper.

Acrylic paint scraped onto packing paper with a credit card, embellished with handmade stamps.

Squeegee technique applied with acrylic paint on thin scrapbook paper embellished with stamps and stencils.

STAINING PAPERS TO GIVE AN ANTIQUE APPEARANCE

I like to include some vintage-look papers in some of my collages: they can be a great, neutral addition and help to tell a story. Once dry, these papers can be printed on with copyright-free medieval or ancient text, which can be found on numerous online sites.

This technique is easy to apply: all you need is cartridge paper, extra-strong coffee (or tea), a roasting tin, kitchen paper, and greaseproof or freezer paper on which to dry the wet paper. Brew your coffee, pour it into a shallow roasting tin and lay your paper inside; leave for 10 minutes (or longer), then remove and dry your stained paper on kitchen paper: place both on top of freezer or greaseproof paper to catch any stains or drips.

Different effects can be made by scrunching or folding the paper first, as shown in the examples below.

From far left: Stained music sheet; stained, crumpled cartridge paper; folded cartridge paper; stained, uncreased printer paper.

Stained tissue papers

Bought coloured tissue papers are non-archival and the colour will bleed when water is brushed over them; however, it is possible to stain your own tissue papers using diluted acrylic paints. I cut my tissue paper to A5 size – 14.8 × 21cm (5⅞ × 8¼in) – for ease and variety but the size is entirely up to you. Staining the tissue also reinforces its delicate nature and makes it more robust for use on a gelli plate.

Lay these papers onto a plastic sheet or bin bag to ensure that all the paint is absorbed by the paper and that they are easy to peel off when dry. Mix together your acrylic colour in a plastic cup or similar, add a little water and some gloss medium (to stabilize the diluted pigment) to form a milky consistency. Finally, brush this onto the tissue from the centre out. Don't worry about any wrinkling that occurs, as this will add texture and interest to your papers.

Try leaving some areas unstained, and go in with a second or even third colour as shown on the right; or try splattering your papers in some areas with a little coffee or tea to produce darker colouring.

A selection of stained tissue papers.

Stained tissue paper is applied to the surface of An Artist's Garden, *pages 87–93.*

Making graffiti papers for collage

I love generating these papers, creating random marks and splashes – it feels very therapeutic to let loose in the studio. I call these graffiti papers but they could also be called scribble papers or even doodle papers. Whatever you choose to call them, they have an amazing impact when incorporated into abstract works, and are a bonus to your collection of collage stash.

You will need some inexpensive drawing paper (I roll out a good amount of lining paper across my work surface), various mark-making tools – be as creative as you like – black Indian ink and white gesso.

1 Flick, splash and daub the ink onto the surface to create random gestural marks. Here, I have used a bamboo skewer, a pipette and a straw, and made spatters with a brush.

2 While the ink is still wet, go in with combs, plastic cards, sticks – anything goes. I've used a comb and a hair roller, spritzed the surface with water to let the ink disperse, and lifted and stamped with bubble wrap to form patterns.

3 Add more marks with white gesso; here, I have used brushes and stamps. You now have some wonderful, bespoke papers to tear up for collage – but see below for another option for your papers before you pull them apart.

IDENTIFYING UNIQUE COMPOSITIONS

Before you tear up your papers, take a viewing mat and go over them to search for any interesting compositions that can become pieces of art in their own right, as shown below.

CREATING A COLLAGE BACKGROUND

This is a great way to start an underpainting and establish composition ideas. Collaging techniques can range from the most simplistic to the more advanced and complex. I personally prefer a simplistic approach, as mixed-media work can prove to be complex, so it's better to keep the components as straightforward as possible.

Adhere collage papers at random to the substrate using matt medium or other adhesive and smooth out any wrinkles or air bubbles with a plastic card or similar tool. You can also give the papers a top coat of medium to protect them from vigorous applications of paint and texture additions. You may choose to preserve some of the collage pieces if they are relevant to the theme of the painting, such as specific words or patterns – in which case, photograph the layout: should the details get lost beneath any subsequent layers, the paint can be lifted using isopropyl alcohol to reveal the treasures beneath.

Neutral coloured background

Here, I have completely covered the substrate with neutral-coloured papers and ephemera, onto which I will then build with paint to establish composition and form.

I have used a neutral background as a basis for The Toolmaker, *on pages 12–17.*

Coloured collage background

Here I have used hand-embellished, coloured collage papers to establish the composition in the first layer, and have built around this with paint to reinforce the shaping and design as a final layer.

Cutting and tearing

I use each of these techniques respectively, depending on whether I want a straight or ragged edge to my collage papers. I also have a small selection of decorative and circle punches for producing a more precise shape.

Handmade papers tear differently from commercial papers – no matter which way you tear them, they will produce a random pattern. Try tearing commercial papers in different directions: you will note that you will get a random effect if torn one way or a straighter effect if torn the other way.

To obtain more control when tearing the papers, paint a line across the piece with a wet paintbrush, which will enable the paper to tear easily along the wet line. You can also use this technique to tear circles, arcs and patterns. To obtain a straight edge, tear against a ruler; use scissors or a scalpel if you require defined edges.

Tearing the paper in a straight line.

Tearing the paper to give a rough edge.

The example on the right shows collage papers with both cut and torn edges.

Preparing and adhering

It is always advisable to coat your papers with a thin layer of matt medium, containing UV protectants to preserve their colour and protect them from harmful UV rays and fading, even though some of the papers may be covered.

Matt medium and gel medium are my products of choice for gluing a collage onto a substrate; however, I will sometimes use PVA glue for heavier papers, or 'YES!' paste (see pages 64–65), which is extremely tacky but has very good adherence properties and doesn't cause buckling.

Once my papers are adhered, I smooth out any air bubbles with a plastic card or a brayer wherever I don't want texture.

Make sure that your collaged layers are completely dry before starting any other layering. If any buckling of larger pieces occurs once dry, turn the piece over, dampen it slightly, weigh it down and let it dry overnight. Small pieces can be simply split open with a craft knife where the buckling appears, and stuck down again.

DIFFERENT APPROACHES TO COLLAGE

There are many different approaches to using collage in your work, from simple additions that enhance a painting, to whole paintings made entirely out of collage papers – see page 112, *On Location*.

Collage is flexible, versatile and offers many possibilities for extending our creativity. It can be realistic, representational or purely abstract; it can be added to, sanded down, covered and torn off, gouged, manipulated or worked into. Use collage to record memories or personal events in a journal, including your own photographs and mementoes – photographs can be scanned and reprinted if you don't want to use the originals.

In the following studies, we explore some enjoyable ways of creating with collage papers and other media. All of the examples on the following two pages were part of an 'Isolation Journal' that I made during the coronavirus pandemic in 2020, which provided me with inspiration and motivation during lockdown.

I suggest that you limit your base paper to around 18 × 18cm (7 × 7in) as I have done here. Try to spend no more than half an hour each on these 'studies', and let your mind run riot!

Creating form or images with collage

I used collage papers to create the form of the hen and the floor of the henhouse, below. I included a feather as a touch of 'reality', and painted in the background and the eggs with brush pens and markers.

Recreating the Masters

Why not select one of your favourite paintings and recreate it using collage? Gustav Klimt (1862–1918) provided the inspiration below. I used patterned papers and chocolate wrappers for some of the design elements, and added a cut-out frame surround to enhance the figures. I added the other design elements using a stencil and black acrylic paint and made further enhancements with a marker pen.

Abstract collage

Try abstracting your thoughts, feelings and aspirations through collage. I combined words and imagery to give this emotive collage study on the left a story during the Covid-19 lockdown in the UK. The theme was 'Waiting'.

Using text in collage

Using text, words and numbers in a collage can be very effective in conveying a narrative – I like to include these components wherever appropriate. I regularly skim through magazines and newsprint to find interesting typefaces, descriptive titles, sentences and words. Poetry, music lyrics, foreign alphabets and other such inspiration can also be particularly emotive.

As an alternative to including type from magazines or papers, you can also create your own words and phrases in a word-processing program, while experimenting with the different fonts available. This text can be printed onto any paper you wish, and cut up and used as collage. I printed text in an old typewriter font onto tissue paper for use in *Above the Mist*, page 72.

Examples of different fonts for collage

EXAMPLES OF DIFFERENT FONTS FOR COLLAGE

Examples of different fonts for collage

EXAMPLES OF DIFFERENT FONTS FOR COLLAGE

Examples of different fonts for collage

Examples of different fonts for collage

Examples of different fonts for collage

Examples of different fonts for collage

Examples of different fonts for collage

EXAMPLES OF DIFFERENT FONTS FOR COLLAGE

Examples of different fonts for collage
A comparison of different fonts available in a word-processing program.

Using souvenirs in collage

Whenever I go away on holiday, I collect pamphlets, maps, newspapers and other such media, which are especially useful if, for example, I am creating a piece inspired by the Tuscan landscape: hints of Italian text and glimpses of a map peeping through all help to evoke atmosphere, memories and the magic of the scene.

Similarly, short passages describing the history or the scene itself all add interest. Seascapes and harbour scenes are great opportunities for adding text: examples could include 'Fish for Tea', 'Beneath the waves', and so on. You can see where I've used torn-up text and numbers on the boats in *Moorings at Low Tide*, opposite, and in *On Location*, below, where I have used descriptive text in various typefaces and weights to convey a story. I have also used this technique on *Brook Beach* (see pages 18–19), where you can see glimpses of the beach's fossil shells if you look closely.

On Location 28 × 35cm (11 × 13¾in)
Pure collage on mixed-media paper.

Note the use of various patterned papers here to create form, and words to tell a story. This form of collage can give great pleasure and allow the imagination to be fully engaged.

Moorings at Low Tide 40 × 50cm (15¾ × 19¾in)

Mixed media on canvas.

I love painting harbours and boats: they are a great inspiration to me and lend themselves perfectly to collage. I find it exciting to spend time searching out various designs and torn-up words in my collage papers to create patterns, texture and interest on the boats, harbour walls and houses. In this particular piece, I have used collage to suggest the texture of the harbour wall and torn text to decorate the boats.

SANDING HEAVILY-LAYERED COLLAGE

This technique of sanding down collage layers can be used to great effect, resulting in a distressed look, reminiscent of old, peeling billboards. I love the grungy effect that this produces and the unexpected results that it renders. It is a little time-consuming laying down the collage, sanding, painting, drying and repeating these steps but the result is well worth it.

I use an electric sander for distressing the layers but you can use a sandpaper block, which will take longer and require more effort. You can also peel back some of the papers manually by spritzing them with a little water first.

MATERIALS AND TOOLS

Surface: Rigid piece of board or wooden block, 23 × 23cm (9 × 9in).

Materials: White or clear gesso; various collage papers; matt medium; PVA glue; glazing medium; acrylic paints in manganese blue, opaque teal, vat orange and opaque yellow; black Indian ink and tissue papers for collage.

Tools: Electric sander or sanding blocks; ice cube tray or dishes to mix the glazes; plastic card for smoothing the papers; flat brushes; soft brush and stamps.

Retro City

Heavily built-up collage layers on a board, ready for sanding.

1 I have already built up plenty of collage layers with a variety of papers on a firm substrate that has been primed with gesso. I have sealed each layer of collage with matt medium before beginning to sand them down in parts to reveal the layers beneath.

2 I began to apply acrylic paint (here, vat orange) that had been mixed with glazing medium to give a translucent effect. (See also, 'Transparency', pages 130-131.)

3 I continued to apply a glaze of manganese blue acrylic paint and left it to dry.

4 I tore collage papers in various directions to produce contrasting edges.

5 In this example, I ripped the paper towards me to create a rough edge that showed the white of the paper beneath.

6 I applied more collage papers to the substrate using matt medium or PVA glue for any thicker collage pieces.

7 I smoothed down these papers using a plastic card to ensure that there were no air bubbles present, and left them to dry.

8 Once dry, I sanded down this new layer of collage.

9 I applied opaque teal acrylic paint to some areas.

10 I continued to build up the paint layers with orange and blue glazes.

11 I applied a last layer of collage and allowed the matt medium and PVA glue to dry.

12 I sanded down this last layer.

13 Next I enhanced the colour blocking with opaque yellow and more of the orange glaze so I had a pleasing colour composition.

14 I placed a printed tissue image (see page 121) onto the piece to create a focal point and carefully adhered this by brushing over with matt medium, using a soft brush.

15 At this point I observed the piece in order to adjust any colour anomalies, and began to add marks by stamping with bottle tops and other tools dipped in black Indian ink to give more form to the design.

16 Finally, I chose appropriate collage text – the word 'Retro' – to describe the scene, and adhered the text in an appropriate place using matt medium.

Retro City
23 × 23cm (9 × 9in)

An instance of using sanding and collage to produce a complex, interesting and exciting collaged work of art that will spark the viewer's curiosity.

ADDING OTHER TEXTURED MATERIALS

Fabric

All sorts of fabric can be used as collage materials, even old net curtains or tablecloths. Look out for interesting patterns and potential materials that will give textures. When you are looking for suitable cloths, find fabrics that don't crease and can be cut easily (you can also use pinking shears or scissors to create an interesting zigzag edge). These collage features can be glued to the substrate in the same way as can paper.

In the example below, I've used a cut-up lace doily as a collage element, to produce a textured section within the painting.

Along Meadow Lane 40 × 50cm (15¾ × 19¾in)
Acrylic paint and ink, Indian ink, collage, lace doily and oil pastel on stretched canvas.

The detail above shows how the lace depicts the heads of the cow parsley beautifully.

Bold texture, or assemblage

I am an avid collector of nature's abundant gifts, be these seashells, driftwood or other artefacts that I have found throughout the years. These treasures can make for interesting assemblage pieces that create mystery and a story all of their own.

HOW TO ADHERE ASSEMBLAGE TO A SUBSTRATE

Because of the often irregular nature of these treasures, I find that the best way to adhere assemblage is to apply a layer of moulding paste or gel medium to the substrate and push the objects into the paste. Wipe off any remaining paste with a cloth and allow to dry thoroughly, then apply colour over any visible pastes to blend in with the painting.

If these items are weighty, it is advisable to adhere them to a wooden substrate or panel; more delicate or lightweight objects can be stuck onto canvas in the same manner, as you can see in the example below.

This reference photograph shows objects found in situ along the River Thames while the tide was out. These 'treasures' were embedded in silt which meant even more interesting scope for interpretation. You can see the resultant finished painting below.

Treasures of the Tide 50 × 40cm (19¾ × 15¾in)
Acrylics, collage and found-object assemblage on canvas.

VEILING AND LIFTING

I use two methods of veiling in my work: the first, to create mystery and depth; the second, to create form.

I like to veil certain areas of a painting, usually with thin applications of white gesso but sometimes with tissue paper or other transparent material, such as deli paper (see page 138). I will also use text or imagery printed onto white tissue paper and adhere it to the substrate to excite the viewer and to indicate a theme or emotion.

VEILING TO CREATE MYSTERY

Using tissue paper

Buff-coloured dressmakers' pattern paper and good-quality white tissue paper are great ways to add veiling to your work. Colour can be used too, but be careful of using commercial coloured tissue paper as it is not archival and will fade over time. See page 105 for details on staining tissue paper.

As well as placing tissue paper over areas to create a veil and a little magic, it can also be printed with text or imagery, which will then 'melt' into the surface of the painting, giving tantalizing glimpses of hidden gems.

Paper Lace
50 × 50cm (19¾ × 19¾in)
Mixed media on canvas. Demonstrating the process of veiling with gesso, lifting and adding transparent text and the use of transparent paper to create transparent layers.

Printing on tissue paper for transparent imagery

Printing on tissue paper is easier than it sounds. All you need is a piece of normal printer paper (which will act as a carrier) and a little photograph mount adhesive to lightly attach the upper edge of the tissue to the printer paper. Make sure there are no creases in the tissue paper, mount it onto the carrier paper and insert into the feeder tray. Once printed, the tissue paper can be removed from the carrier paper.

Here, I have printed an old sea chart onto the tissue. Once incorporated into a painting, the clear parts of the tissue will 'soften' into the background.

VEILING TO CREATE FORM

This is an example of how your waste paint paper palette (see page 94) can provide inspiration for development and trigger the imagination. Using white gesso, I create shaping by veiling over all the negative spaces around the colours to produce an image or create form.

Watermelon Woman

In this demonstration, I will be transforming a waste paint palette paper into a finished painting.

MATERIALS AND TOOLS

Surface: Watercolour paper, 28 × 38cm (11 × 15in).
Materials: Art bars in green, red, bright yellow, orange; painted tissue papers; collage papers including paper napkins; white pastel; coloured pencils in violet, red and black; yellow oil pastel in yellow and white gesso.
Tools: Tear-off paper palette; kitchen paper; flat paintbrush; water spray bottle; palette knife and scissors.

1 Look at the colourful surface of your waste paint palette paper, what can you see? Turn it upside-down and on its side and search for obvious shapes or promising forms. On this one of mine, the first possibility that jumped out at me was the purple shape at the top that I felt could represent a head, maybe in a turban. The splashes of colour could represent a bowl of fruit, flowers or something similar.

2 I outlined the identified form in white pastel: this enabled me to make adjustments and changes as the pastel can easily be dusted away once I've established the structure.

3 I painted out the negative shapes with white gesso, applied with damp kitchen paper.

4 I then developed the piece by adding paint, collage and dry media to enhance the shapes. I used water-soluble art bars here in green and red, which had been dipped in water to release the pigment, to create the dress, the watermelon and other fruit. I decided to keep the lilac-pink colours of the skin tones as they were, as I thought this added vibrancy and energy to the figure and complemented the other colours perfectly – I believe this is known as 'artistic licence'!

5 I created the headdress with scrunched-up hand-painted tissue paper in yellow and green applied with matt medium.

6 I then added more collage elements in the form of cut-up sections of paper napkins (I separated the top layer from the plies underneath – there are usually about three) to form the dress. Because the ply of the napkin was so thin, these collage pieces could be adhered by carefully painting matt medium over the top of them.

7 A tropical theme was taking shape so by adhering more paper napkin collage depicting a lemon and some palm leaves, the painting began to have meaning and a touch of the 'exotic'.

8 Using a bright yellow art bar dipped in water, I embellished the turban and introduced some necklace beads.

9 I outlined the figure with violet coloured pencil to make her stand out.

10 I then pushed back the negative areas further with some more white gesso.

11 Further embellishments to the necklace were made with a wet orange art bar.

12 I drew in the seeds of the watermelon using red and black coloured pencil marks.

13 Finally, I added the last touches using yellow oil pastel for some texture and contrast.

Watermelon Woman 28 × 38cm (11 × 15in)
Watermelon Woman illustrates how, by careful observation and creative execution, a meaningful, fun image can be created from a jumble of leftover paint colours.

LIFTING

Opposite to the process of 'veiling', I will 'lift' paint in other areas with isopropyl alcohol and other mediums to reveal what has gone before, to provide the viewer with insights as to the history and the creation of the work.

Most wet media can be lifted by simply rubbing or blotting with wet kitchen paper or lifting with a damp brush. Dry media such as charcoal, pastel and graphite can be lifted using an eraser or a dry rag, and oil pastel and paint can be lifted by using thinners. However, because acrylic paint contains a polymer, once dry, it can be difficult – sometimes impossible – to shift it. Here are various ways in which you can lift acrylic paint.

Lifting with isopropyl alcohol through a stencil on dry acrylic paint
You can see the underlying blue layer in places where the paint has been lifted right through to the white surface.

Blotting and smoothing
Apply a second coat of paint to the first layer and lay a smooth cloth on top; blot down firmly and smooth out with your hands. Lift off the cloth.

Creating texture with scrunched-up kitchen paper
Use a scrunched-up sheet of kitchen paper to lift wet paint from a previously dry layer.

Lifting layers of paint with a stamp
Stamp into a second layer of wet paint to reveal the initial coat, creating patterns.

Scaping into wet paint
Scrape into dry paint to reveal its subtle underlayer, or score in with a sharp object – in this case a wedged palette knife – to reveal the white of the paper.

Blotting and lifting
This is another blotting technique; here, a piece of paper has been placed onto the wet paint and immediately pulled away.

VEILING AND LIFTING WITH GESSO AND PAINT

Practise veiling, lifting, and developing any old paintings that you have and see if this technique adds any sparkle or 'wow' factor.

Cut them up into smaller sizes and create a series, as I have done in the studies below. Add marks with stamps and stencils, add a little collage – experiment and see how far you can take this technique. I am sure that you will be surprised at the effects this process can produce.

Lifting and veiling

Small 20 × 20cm (8 × 8in) studies cut from a larger abandoned painting.

Here I have created three individual paintings from an old, seemingly unworkable piece. I used techniques of lifting the paint in parts and veiling in others. Finally, the paintings were embellished using stamps and stencils to produce a cohesive design.

Urban Excavation 30 × 30cm (11¾ × 11¾in)

Collage, acrylic and Indian ink, tissue paper imagery on board.

I began this painting using the collage, paint and sanding technique explained on pages 114–117. I printed out the image of the cityscape onto tissue paper as outlined on pages 116 and 121, and carefully adhered it to the substrate using matt medium and a soft brush to prevent tearing.

TRANSPARENCY

Adding transparency to a painting can give it beautiful depth of colour and create intrigue. Certain pigments in paints are naturally more transparent than others and this will normally be indicated somewhere on the tube. These paints can be used directly to create a transparent layer. Opaque acrylic paints can be made transparent by adding a glazing medium to them.

THE BEAUTY OF GLAZING

Towards the completion of a painting, I often use a coloured glaze in some parts of the dry areas. However, it is also interesting to complete a painting entirely with glazes.

The glazes I employ consist of either transparent fluid acrylics, transparent acrylic ink, watercolour inks or the addition of a glazing medium to an opaque acrylic paint, to deepen and enhance a colour. Used on top of dry layers, glazing can change the chroma, value, hue and texture of your painting. See the example below, right, where I've used multiple acrylic glazes to create an intensity of colour.

Using glazing liquid or medium instead of water

Glazing medium contains a binder that will help disperse the pigments in the paint more evenly, resulting in a much smoother finish than when using only water. Glaze is normally mixed in the ratio of 90 per cent medium and 10 per cent paint, but feel free to experiment until you achieve your desired consistency. Opaque paint will require more glazing medium than translucent paint will. Each layer must be bone-dry before you apply any subsequent layers.

MIXING GLAZES

I use an old ice cube tray to mix my paint with glazing medium. This is particularly handy if you have glazes left over as the tray can be covered to stop the glazes drying out overnight.

Ice and a Slice 30 × 40cm (11¾ × 15¾in)
On paper, acrylic glazes.
I began this painting with an initial coat of yellow acrylic paint. A number of acrylic paints and inks were mixed with glazing medium to create beautiful transparent colours, which were brushed over the first application of yellow in colour blocks of separate layers. Each layer was allowed to dry thoroughly before the next was applied. Further coloured glazes were added in the form of shapes to complete the painting.

Examples of different mediums and their glazing properties

Glazing with acrylic inks on primed watercolour paper.
Notice how the glazes mix to produce an even application of colour without brushstrokes.

Glazing with acrylic inks on unprimed watercolour paper.
You will see how the liquid inks have been absorbed into the surface.

Glazing with watercolour inks without the addition of glazing medium.
As these inks are not water-resistant when dry, you can see how the underlayer has blended in with the second application of glaze, causing an interesting transition of colours.

Glazing with watercolour inks mixed with glazing medium.
You will note that the first layer of inks bleed into one another, while the second layer has been mixed with glazing medium. This will stabilize the mixture slightly, eliminating any pronounced bleeding.

Glazing with acrylic paints mixed with glazing medium.
This is similar to using acrylic inks in the top-left example, but here the brushstrokes show through.

Glazing with acrylic paints and a high proportion of glazing medium.
Using a higher proportion of medium causes interesting resists from the previous layer.

Adding transparency with hand-decorated deli papers

The photographs below show how patterned paint and ink works well on deli papers to provide transparent decoration and interest; as you can see, the underlying imagery shows through. Acrylic paint, marker pens and gel pens have been used here.

Adding transparency with collage

GLAZING OVER COLLAGE PAPERS

As well as using naturally transparent collage papers from your stash and hand-staining tissue papers, you can also create interesting colour effects and transparency by glazing over coloured collage papers, as shown in the example, right. I also upcycle my deli paper by using it to wipe off my waste paint or palette leftovers, resulting in more patterned paper to use for future collaging.

A Day at Chelsea 38 × 28cm (15 × 11in)

Mixed media and glazes on paper.

There's a lot going on in this painting, and the depth of the colour is built up through various glazes. The background is particularly interesting as it evokes a sunny summer's day at the Chelsea Flower Show. Small pieces of obscured collaged text add to the story of the day.

PRINTING

PRINTING TOOLS

I've always been fascinated by printing and have experimented with a few modest printing techniques from monoprinting to creating my own simple collograph plates, stamps and stencils. This all adds to the excitement of mixed-media art.

I've listed the main tools that I use in printing; there are many more if you wish to explore this fascinating subject further.

Brayers

These rollers are invaluable tools for spreading paint around on the substrate, blending different colours and creating a surface on which to make monoprints or applying other such printing techniques. Brayers come in many sizes and widths.

Printing tools

1. Sequin waste
2. Assorted stencils
3. Handmade polystyrene and foam stamps
4. Self-adhesive foam
5. Stencil making tool
6. Manufactured stamps and mark-making tools (see also page 144)
7. Gelli plate
8. Brayer

Stamps

I own stamps of all sorts of shapes and sizes that I have collected over the years, and I also make my own by various means. Making a stamp can be as simple as sticking a piece of shaped card onto a thicker base and sealing it with some matt medium, or cutting negative shapes out of corrugated card to reveal the bumpy texture.

I also use adhesive craft foam cut and formed into shapes, and attached to a polystyrene base – see below for an example of how these can be made.

Adhesive-foam stamps on a polystyrene base.

MAKING YOUR OWN STAMPS

Making your own stamps allows you to customize your designs to suit your needs – it's also much cheaper than buying commercial stamps.

1 For this particular example, I cut thin strips of foam from the sheet. Any shapes or forms can be cut very easily and applied to the polystyrene base.

2 I peeled the backing from the foam.

3 I then twisted the strips into spirals, and adhered them to the base.

The completed polystyrene stamp.

Stencils

As well as my collection of stamps, I have a collection of various stencils, both manufactured and handmade. I own an electric stencil tool (shown below) that consists of a very fine tip that becomes hot to enable intricate patterns to be made on thin Perspex, Mylar™ sheets or acetate. This technique can be seen in action on pages 160–163, where I apply design elements in the form of a heart stencil to reconstruct an old painting.

My electric stencil tool and an example of how I have used this to create a handmade stencil.

MAKING YOUR OWN STENCILS

It can be equally satisfying to create your own stencils. My electric stencil tool has a fine point that heats up and cuts through acetate or Mylar sheeting, but you can use a scalpel or craft knife to do the cutting.

I've selected some heart motifs with which to demonstrate this technique, and will use the stencils in the design exercise on pages 161–163.

1 I placed the printed image underneath a plate of glass and secured the acetate sheet to the glass with tape.

2 Once the stencil tool had heated, I traced the outline of the image, cutting through the acetate sheet.

3 I continued to do this with the smaller, more intricate shapes until all the trace lines had been cut.

4 I punched out the negative shapes, placed the new stencil onto paper and, finally, brayered over it with paint.

PRINTMAKING METHODS

Printmaking is a subject that can occupy a very broad spectrum of techniques and explorations, but for the purpose of this book, it is my intention to give only an overview of some simplified methods that you can include in your mixed-media work.

Deli paper

Deli paper is a fine, dry wax paper that was originally used as food wrapping. I used to have problems getting my hands on this paper as it seemed to only be available in the US. Thankfully, with the increase in popularity of gelli-plate printing, deli paper is more widely available in the UK and elsewhere. It's lightweight, strong and beautifully translucent. I often use deli paper to build up layers of colour, revealing hints of the layers below. This lightweight paper is waxed on one side and accepts both paint and dye with ease.

Texture plates

I have a number of texture plates, which I use to create pattern on the gelli plate, and also to make texture by placing them under paper and scraping paint over with a credit card to reveal the pattern and texture.

The example above shows how deli paper can be used to good effect using stamps.

Acrylic paint scraped onto brown packing paper over a texture plate.

Printing methods using the gelli plate

As I've mentioned previously on page 102, using a gelli plate to create beautiful imagery, pattern and design on paper is an obsession of mine. Below, I give a brief overview of basic ways to create exciting papers using simple methods and materials. It's worth watching online videos as well, if you wish to explore this fascinating printing method further.

USING A TEXTURE PLATE WITH THE GELLI PLATE

I use various tools to build up the design of the texture plate, some of which are inexpensive, shop-bought plates, available in a variety of designs. The designs on these texture plates are transferred to the gelli plate by pressing them into the wet paint and then carefully removing them. Paper is then placed on top of the inscribed design on the gelli plate, burnished with your hand and then pulled away to reveal the print on the paper.

DABBING WITH A PEN

Numerous marks can also be made into the wet paint using any tools that you have – below, I have used the end of a pen to create circles. Never use sharp objects on your gelli plate as these will cause damage to the plate.

USING A STENCIL

Stencils are also a great way to transform a pattern to a print. You can either press the stencil into the wet paint and remove it before applying and burnishing the paper (as I did with the texture plate above) or you can leave the stencil on the gelli plate, apply your chosen paper, burnish with your hand and peel away the paper. Each option will produce a different effect and print.

CREATING HALF-LAYERS/MAKING A 'RAINBOW ROLL'

You can add multiple layers to your plate to create colourful results – this is known as a 'rainbow roll'. Layer two or three colours next to one another on the plate with your brayer, letting some of the colour overlap in places.

USING A STAMP WITH THE GELLI PLATE

Another way to add design is with a stamp. I find that intricate wooden Indian stamps work perfectly here, but any stamp will suffice. Press your chosen stamp into the wet paint and repeat the design as many times as you like. The pattern will transfer to your paper when the print is pulled.

PRINTING TEXT

If you wish to apply text to your print, note that the characters will be reversed. However, it is easy to make your own stamps for this purpose by adhering cut-out letters back-to-front to a block of polystyrene.

I use a number of stamps on which the text is illegible; it makes for some truly interesting marks.

Gelli plate prints

Far left: Gelli plate inked up as a rainbow roll with a stamp design in the form of a fish.

Left: The results of a print pulled from three different applications of paint on the gelli plate.

MAKING GHOST PRINTS

If you have paint left over on your gelli plate after pulling the first print, pull a second print – this is known as a ghost print and can be most interesting with subtle markings and low-relief textures. I use these ghost prints to transfer leftover paint to luggage labels (right), which enables me to create multiple layers of pattern and design.

Below: Any leftover paint on the gelli plate can used to pull a 'ghost print'. Never waste any paint!

Layers of ghost prints taken from the leftover paint on the gelli plate, once the original print has been pulled.

Making collograph prints with acrylic paints

I also make my own simple collograph plates. A collograph is a term used to describe a print pulled from a plate made up of collage materials. These can be simple or complex but are always very effective. Using everyday materials such as masking tape, netting, fibres and paper adhered to a piece of card is the simplest way to make a collograph plate. Care must be taken to ensure that the chosen elements are evenly attached to give a good print.

1 Ink up the plate with acrylic paint using a brayer. Place the painted plate onto a piece of paper and burnish with your hand.

2 Peel off the plate to reveal the transferred image.

The collograph print.

On the far left is the original collograph plate: I created texture with torn up-masking tape and vegetable netting, and adhered thin threads to the card. I then brayered over the plate with blue Open acrylic paint and burnished the paper down on top.

On the left is the print, which has picked up the texture perfectly. I've used very simple materials to create a plate but the resulting print is fascinating.

Summer Flowers 27 × 27cm (10½ × 10½in)
Layered monoprint on packing paper.

Use a viewing mat to identify any interesting compositions in your prints – sometimes these can form an image in its own right, which is how the painting above came about.

MARK-MAKING

Mark-making techniques can add fun, dimension and interest to your work. The marks can be as simple or as complex as you like; they can often transform a piece that is looking for something 'extra', and elevate it to stardom.

TREASURE IS EVERYWHERE!

Take a look around your home and see what treasures you can discover to make marks on your substrate. A few examples are bamboo skewers, hair rollers, hair combs, basting brushes, toy building bricks, toy train tracks, pastry cutters, window squeegees, bottle tops, forks and draught pieces to name but a few.

A selection of some of the natural and manmade found objects used as tools in mark-making over the next few pages.

Here are a few examples of marks made with all sorts of wonderful objects. All of the marks shown in these examples are made with Indian ink, but paint and other inks can be used with success.

Twigs

Fork

Comb

Pastry brush

Crescent-shaped pastry cutter

Fluted pastry cutter

Plastic plug pin protector

Hair roller

Plastic building brick used with acrylic paint

Toy wheel

Hair-dyeing comb

Bottle stopper

146

Mixing the media

Toy wheel

Metal bottle cap

Textured plastic strip

The resultant marks.

147

Mixing the media

ADDING MARKS

There are many marks that you can incorporate into your painting to create more interest and meaning. These marks can be made in wet media, dry media or even collage.

In the two paintings illustrated below, you will see how simple mark-making has transformed the pieces from what may otherwise have been meaningless forms, to add content, variety, repetition, liveliness and excitement and draw the viewer into the mystery that has been created.

Dreamcatcher 35 × 28cm (13¾ × 11in)
Inks, oil pastels, gel pens, acrylic washes on watercolour paper.
Note how the drawn-in symbols depict the essence of a dreamcatcher rather than its true structure.

Daydreamer 35 × 24cm (13¾ × 9½in)

Inks, oil pastel, gel pens, acrylic paint on watercolour paper.

More symbolism and marks drawn in give the viewer a deeper feel of the subject.

Mark-making using symbols

Using symbolism in your art can make a piece more expressive and convey a thought or idea that leads the viewer into its narrative. Symbols can reflect history, culture or religion: think of hieroglyphics, or native American or Aboriginal signs and icons; Celtic knots, Scandinavian runes; the ankh, the cross.

Associated symbolism can include marks that reflect the nature or essence of a piece – such as a boat, a shell or fish shapes within an abstract seascape. Symbols can also be used to suggest a recognized cultural icon of that country such as chopsticks (China), fans (Spain) and an eagle (the US).

Other symbols can be more tangible such as skulls, star signs, yin/yang, hearts, flowers, runes and animals.

Popular representations include:
- The dove as a symbol of peace;
- A red rose heart to portray love or romance;
- A ladder, which may stand as a symbol for the connection between heaven and earth;
- A butterfly, signifying transformation;
- A cross, signifying spirituality.

Illegible handwriting used as symbolism in The Pagan, *shown in full on pages 158–159.*

An ankh and a heart.

A dove and a butterfly.

Study: Sunrise over Temple at Abydos
42 × 32cm (16½ × 12½in)
Collage and coloured encaustic waxes on papyrus paper, embellished with marker pens. Notice the painted ankh details.

Flower details, from Dreamcatcher, *shown in full on page 148.*

Colour also plays its part in symbolism, creating a mood, atmosphere or connection:
- White, for purity and peace;
- Black, for sorrow or darkness;
- Red, for passion and fire;
- Blue, for harmony or ice;
- Yellow, for joy, sunshine or spring;
- Green, for growth and nature;
- Purple, for spirit, royalty or mystery;
- Orange, for warmth and happiness;
- Brown, for autumn or solidity.

An enclosed circle in white, representing purity or peace.

A yellow flower, representing joy or sunshine.

A leaf frond from a plant, representing growth and nature.

A red flame, representing passion or fire.

CREATING YOUR OWN PERSONAL IMAGERY AND SYMBOLISM

Some artists like to include their own personal symbolism in their work, which can prove a powerful addition to a theme – the portrayal of the essence of a subject rather than its form – or to provide a visual communication to the viewer.

My personal symbolism is reflected in certain favourite shapes that I will feature over and over again, such as circles (see right) and curves, and the use of particular mark-making tools that I have collected over the years.

Please note that symbols do not have to be complex or overused in order to create impact. Whatever symbolism you choose to include in your art, using stamps and stencils can be an interesting way to apply these and can be custom-made, adding yet another personal touch to your creativity.

Stamped circle details from Moonrise across the Field, *shown in full on page 78.*

Other mark-making techniques

Other forms of mark-making use numerous creative techniques: energetic marks can be made by employing dry media, spray paints, fluid paints, texture pastes and gels, along with found items. Take a stroll around your neighbourhood and see what treasures nature has to offer – twigs, leaves, shells, grasses, tree bark and pine cones are a few examples.

Now that you have these riches, how to apply them? Dip them in ink or paint, and stamp, roll, stencil and brush them onto your surface – experiment to see what works for you.

SPONGE AND SEQUIN WASTE

Above: Sequin waste can be used as a stencil (left) or flipped over to create a negative effect in the form of a stamp (right).

Left: Natural sponges give a beautiful texture when dipped lightly in paint and sponged onto the surface.

SALT AND COFFEE

Salt can be sprinkled onto a surface of wet paint or ink and removed when dry, leaving behind a beautiful pattern. On the left, fine salt has been sprinkled at the top of the sample, and coarse salt at the bottom.

Coffee grounds can also be sprinkled on a surface, wetted and left to dry to leave an organic stain on the substrate; however, these stains are not archival and may fade over time. Tea may also be used in a similar manner. On the right, both coarse and fine grounds have been used to create different effects.

PLASTIC FOOD WRAP AND OLD PLASTIC CARDS

Plastic food wrap can be pleated (left) or scrunched (right) and used to make organic patterns. Lay the plastic wrap – either scrunched or pleated – into the wet paint and allow to dry before peeling off.

Care must be taken when using this method with acrylic paints as the film can become embedded in the acrylic, so I tend to remove the film before the paint is fully dry.

Old credit cards can be used on their sides to create linear marks, and stamped, dragged or twisted around for more dynamic marks.

Mark-making onto wet media

There are many effects that can be applied to wet paint to produce even more variety in your mark-making.

WATER-RESIST PATTERNED PAPER

Apply a layer of paint to your substrate. While your layer of paint is still damp, finely spritz on some water droplets with a spray bottle, wait for a few seconds, then blot them off. The water will act as a resist and lift the shapes from the layer of paint.

Alternatively, do the same, only this time draw marks and drop water into the damp paint using a pipette, wait a few seconds, then blot off the water.

Pipette method *Spritz method*

BLOWING THROUGH A STRAW

While your first layer of paint is still wet, drop on some ink and blow through a straw to move the ink around. As the first layer of paint is still wet, the ink will combine with it and produce exciting organic marks.

SCORING AND EMBEDDING

Score into wet paint with a bamboo skewer or similar tool and press different objects into the paint. In the example below, I have used bottle tops and paint lids.

ISOPROPYL ALCOHOL

This can be applied to the wet-media surface by splashing, drawing or dropping in with a pipette, or by spritzing onto wet paint to create glorious organic effects as shown below.

INCISING WITH SCRUNCHED-UP PAPER

Scrunch up some paper (try soft tissue paper or printer paper and see the different results) and blot onto wet paint. The marks can be very subtle. Try twisting the scrunched-up paper into the paint to make incised marks.

Mark-making onto dry media

Here are some other mark-making techniques you can try once the paint is dry.

USING INDIAN INK, A STRAW AND A COMB

Use a pipette to doodle marks in Indian ink, then blow through a straw to disperse the inks in a random fashion over the dry media. Next, taking a comb, pastry brush or similar tool, draw out the wet ink to form organic shapes and marks.

USING A WAX RESIST

Apply marks with a wax candle or oil pastel onto the surface and paint over them with a thin layer of acrylic paint or transparent ink. The wax will resist the paint and produce a glorious effect. Try doing this on one layer of colour and then glazing over with another colour; all manner of interesting marks can be seen through the layers.

SPATTERING

Make sure your paint is of a runny consistency and coat an old toothbrush with the paint; run your fingers over the bristles and spatter the paint onto the surface.

Alternatively, load a rounded brush with diluted paint and tap it against a second brush handle or a similar rigid tool to create spatters and lines.

Try out various spattering techniques with items such as a toothbrush, a paintbrush – even a bamboo skewer dipped in ink.

A. Using a toothbrush. *B. Using a paintbrush.*

USING WATER-SOLUBLE MEDIA TO CREATE RUNS

Draw marks with water-soluble media such as charcoal, Inktense pencils and art bars at the top of your surface, spritz with water, tilt your paper and create colour blends and runs down the substrate.

USING A BRUSH OR PALETTE KNIFE TO STAMP ON MARKS

Using different-shaped brushes, or palette knives, load with paint and, instead of brushing on marks, use the brush or knife shape to stamp onto the dry layer. In the example below I have used various brushes (round, fan and flat) and a palette knife to produce the starfish shape in the top right.

RAINBOW SCRIBBLING

Hold four or five coloured pencils in one hand and scribble across your surface. These scribbles will produce energetic marks.

SPRAYING PAINT THROUGH A STENCIL

Make sure you are wearing a mask for this process, and that you're working in a well-ventilated room. Tape down the stencil onto your substrate and spray paint through it. Leave for a few seconds, then remove the stencil.

ILLEGIBLE WRITING

Write or scrawl with a bamboo skewer dipped in ink, rather like doodling, in the form of written letters. The lower letters on the right were created by turning the skewer slightly on its side. You can also try writing with the wooden end of a brush.

All of these examples of mark-making can be applied to individual collage papers and used in your work, as shown in the study below.

Experiment and play with lines and shapes: see what compels you to create your own personal symbols and imagery. Keep a small notebook handy and record these revelations whenever or wherever you find them, be these in your imagination, nature, magazines or in everyday objects.

Further mark-making effects

If you need further inspiration, consider using corrugated card to print or stamp patterns on your surface. Skewers and knives can also be used to scratch fine lines into dry paint.

Collage created with hand-patterned papers, and decorated using mark-making techniques described in this section.

The Pagan 40 × 40cm (15¾ × 15¾in)
On stretched canvas.

Notice the energetic marks on the upper right, representing a flight of ravens and the stamped-on symbols forming the focal point representing pagan ritual. To add even more interest, I wrote the words 'The Pagan walks between the stones waiting for the sign...' in freehand.

This is also an example of how I reworked an old painting, covering the surface with white gesso and applying acrylic, collage and Indian ink. Some of the original textures still show through.

Never discard an old, seemingly unworkable painting.

159

Mixing the media

APPLYING DESIGN ELEMENTS

Adding design elements can transform a very simple application of paint into a truly noteworthy finished painting.

The two examples below show how design can be used to achieve this, by adding marks and interest to nearly-completed paintings, using stamps, stencils and collage:

A Walk Through the Orchard
Layers of paint, collage, stamps and stencils.

Floral Maze
Layers of paint, collage, stamps and stencils.

Transforming an old painting using the principles of design

In the following demonstration, we look at how an old painting or study can be transformed into a series of four smaller, stand-alone paintings, by using the principles and elements of design outlined on page 42.

The image below, left, was a very old experiment in using bright colours, mark-making and bold expression. As a painting, it was far too busy but proved perfect for a makeover.

You can do a similar thing with any old, brightly-coloured painting you are not happy with – alternatively you can fill a sheet of paper with a myriad random colours, textures and marks for this purpose. Divide up your painting into four sections using masking tape, as shown below, right, and fill these quadrants with design features all based on a single motif.

The original experiment using colour and bold expression.

Four sections, cut from the original. Here you can immediately see that there is plenty of potential to develop these segments using design elements.

APPLYING THE HEART MOTIFS

To start, I have designed a heart motif, which I have then created out of handmade stencils in the first two examples and a foam stamp on a polystyrene block in the second two examples. See page 137 for the explanation on how I cut the stencils using an electric tool.

1 I tested out my hand-cut heart stencil on some scrap paper using a brayer filled with blue acrylic paint.

2 I lifted off the acetate to reveal the result, which I was pleased with.

3 I applied the solid heart shape in blue to one of the predominantly red paintings and the outline stencil to the other.

4 I used the outline heart stencil with red acrylic paint for the predominantly blue painting and the solid heart shape to the other.

5 I applied more red paint to my handmade heart stamp.

6 This was stamped onto the blue paintings in a random but compositional direction; I repeated the process using blue paint on the red paintings.

7 Using a mat around each piece, I made final placement decisions for each of the four individual pieces.

> **If all else fails…**
> *If for whatever reason you are unhappy with the outcome of your makeover or resurrection, and you have created the works on paper, you can still make use of the resultant studies and cut up the papers for use in collage elsewhere.*

These four separate paintings show how applying design elements in the form of motifs, shapes and marks can give a colourful busy background unity, contrast, rhythm and harmony.

ACCENTUATING THE FOCAL POINT

Most of the time it's obvious where the focal point of your painting is, but sometimes it can prove very subtle. Take a look at the painting *Lobster Pots* on page 77 – at first glance there doesn't seem to be an obvious focal point, but the zigzag composition leads the viewer's eye to the narrow red house on the upper right. You will note that the house is smaller in scale with more features (a window and a door), which provides a contrast to the other houses surrounding it, and enables it to become the focal point of the painting – known as a directional focal point.

Other ways in which to accentuate your focal point are through providing contrast in colour, shape, tone, size, pattern, texture or temperature, for example. Alternatively, you can place a frame around a single element, or isolate a single element from the rest of the painting.

In the examples below, I have chosen an abstract floral theme to depict a variety of ways to make the focal points 'pop'. Create some similar exercises of your own, use muted or vibrant colour combinations, use collage if you like and don't forget to have fun! Think of the focal point as the Star of the Show, and the other elements as the supporting cast.

Top row:

Left: I have used a warm colour to contrast with the cooler colours of the study and made the 'star' flower a larger size.

Middle: Here, in this monochromatic colour scheme, I have used pattern to accentuate the focal point, which is very different from the rest of the patterns used to represent the flowers.

Right: Scale is used again here, but I have also isolated the larger flower which stands out away from the main grouping.

Bottom row:

Left: This shows an example of using shape: as you can see, the jagged shape of the flower on the right stands out from its more regular-shaped neighbours.

Middle: I love using complementary colour schemes and here you will see that I've added a spice colour to form a frame of sorts around the lighter-coloured lilac flower, which immediately demands attention.

Right: In this last example, I have used bold contrast in tone and colour to make the white flower the star here.

Ikebana 26 × 35cm (10¼ × 13¾in)

Mixed media on paper.

Although the three stencilled flowers are grouped together, the middle-most flower, with the darkest centre, becomes the focal point. It has also been framed by the collaged lace doily, which has created a partial halo effect.

ADDING ACCENTS IN DRY MEDIA

Dry media can supply an interesting contrast and finishing touch to the build-up of painterly layers. By adding accents to your final layers, you will take the piece to its conclusion.

These include but are not limited to:

- Pan pastels;
- Soft pastels;
- Pastel pencils;
- Oil pastels;
- Coloured pencils;
- Water-soluble pencils;
- Gel pens and markers;
- Fine liners;
- White and black charcoal;
- Collage or light assemblage;
- Text.

The following studies show various ways in which you can use dry media to make accents and emphasis to 'bring a painting together'. The study below shows a variety of dry media, used to enhance and enliven static areas of colour.

Top row:

Left: The use of coloured pencil scribbles gives this cruciform composition energy and liveliness.

Middle: Here, I have used felt-tip pens to highlight the circles and form a series of patterns to add a vibrancy in what is a low-key colour scheme.

Right: I have applied black fine liner pen to join together the design elements in this simple study, and have drawn in subtle lines of white charcoal pencil to add depth.

Bottom row:

Left: Pan pastel has been applied through a stencil to accentuate the scenic quality of this example.

Middle: The overlapping frame composition has been emphasized with more frames cut out of collage paper, and some collaged numbers added for interest and to provide a focal point.

Right: In this last example, I have used white gel pen to add some loose script and organic circles to contrast with the linear composition.

Adding dry media

This exercise will encourage you to experiment with various types of dry media and ways in which they can be used to add accents. Divide up a sheet of paper into six sections. Using a very basic compositional format, divide each section into thirds and place a simple shaped object overlapping the axis point – for the purpose of this exercise, I have illustrated an orange.

Simple repeated compositional studies ready for the application of accents in dry media.

Start to apply various mark-making strokes, and concentrate on developing the form of the object. Don't think too much – be spontaneous. Have fun with colour but keep the dominant object a similar hue in each example, so that it will be easier for you to compare the differences between the effects of the dry media.

Note how simply adding these dry-media accents produces interest, impact and contrast to a rudimentary composition.

Keep these results in mind when developing a painting, especially if you hit a creative block – they could be the solution you are looking for, or could even take you in a new direction.

The compositional studies with dry media accents added.

Top left: Marker pen and white gel pen;
Top middle: Rainbow scribbles with Inktense pencils;
Top right: Grey, white and black charcoal;
Bottom left: Soft pastels;
Bottom middle: Oil pastels;
Bottom right: Brusho (activated with water).

RED LILIES

In this final demonstration, I show you various stages of creating a simple but effective mixed-media floral collage, using an assortment of papers to create texture and interest.

The reference photograph.

MATERIALS AND TOOLS

Surface: Mixed-media paper, 21 × 29.7cm (8¼ × 11¾in).

Materials: Acrylic paints in cadmium red, ultramarine blue, indigo, magenta, titanium white; white charcoal; white gesso; Inktense pencils in Chinese ink and spring green; oil pastels in green and pink; collage papers, including CitraSolv papers, decoupage papers and lace paper; sequin waste and matt medium.

Tools: Brayer; sheet of Perspex; flat brushes; spray bottle of water; kitchen paper and cosmetic sponge.

1 Using the Perspex sheet as my palette, I rolled cadmium red acrylic paint onto the brayer.

2 I lightly sprayed the mixed-media paper with water and rolled out a red paint layer across the top half.

3 I followed this by brayering a magenta layer across the middle section and finally a blue layer of acrylic paint across the lower part, allowing each layer to dry between applications.

4 Using my reference photograph, opposite as a basis, I mapped out a loose composition with white charcoal to represent the floral shape and create the glass vase.

5 I applied white gesso with a damp sheet of kitchen paper to create the negative shaping of the background around the flowers and to highlight areas of the glass vase.

6 I applied a rough mix of ultramarine blue and indigo directly onto the paper to establish the negative spacing and to paint a stroke of blue across the vase to give the illusion of a water line.

7 I adhered collage elements, including CitraSolv papers, with matt medium within the vase to represent the flower stalks.

8 The petals were formed using shapes cut and torn from decoupage papers; I applied these in a random fashion and added a separate piece to the lower-right for balance, together with a piece of lace paper.

9 I developed the petals using a thick application of cadmium red straight from the tube.

10 I outlined the form of the flowers with an Inktense pencil in Chinese ink, and spritzed with water to diffuse the pigment.

11 I introduced more collage papers to accentuate the leaves with yellow lace paper adhered with matt medium.

12 Using an Inktense pencil in spring green, I drew in the stamens and spritzed again with water to diffuse the pigment.

13 I chose the meaningful word 'Exotic' to portray the mood of the painting, and placed it to the right of the petals as a focal point.

14 I developed the design by stencilling white paint through some sequin waste with a cosmetic sponge.

Note

When using tools to stamp paint onto your surface, remove any excess paint beforehand onto a scrap of paper set aside for waste paint, otherwise your stamp will smudge.

Similarly, when using a stencil, blot off any excess paint on your applicator first. I like to use cosmetic sponges rather than brushes when applying paint through a stencil, although this is a personal choice. If you do use a brush, make sure it is bone-dry, otherwise bleeding will occur. I prefer to use a cosmetic sponge as the smoothness of the sponge makes it easier to apply the paint, and reduces the risk of any colour bleeding underneath the stencil. A sponge is also easy to reuse – simply cut off the end where the paint has been applied, and you have a fresh sponge.

15 I enhanced the water line in the vase with white gesso.

16 Finally, I redefined the detail of the flower stamens using green oil pastel.

Red Lilies 21 × 29.7cm (8¼ × 11¾in)

This is an example of how to produce simple abstracted forms from everyday flowers, to produce visual impact and a bold colour statement.

VARNISHING AND COMPLETING

Now you've potentially reached the stage where you are satisfied with your work and wish to display it to its best advantage – however, you may still have some questions to ask yourself.

Is the piece truly finished? If you have to ask the question, then it probably isn't – perhaps it needs only a small tweak, accent or highlight to give it the wow factor. Or perhaps you're getting to the stage where you are nervous about adding any more to your work.

- Put the piece away for a few days and revisit it with fresh eyes;
- Examine it through a mirror to reveal any compositional imperfections;
- Print out an image of the painting, and make adjustments to the printout rather than the painting to see what might work;
- Make any adjustments in soft pastel as these can be wiped off later.

Once you are satisfied that the piece has reached completion, display your finished masterpiece in your home. Don't forget to sign it as a final flourish.

Varnishing

I tend not to varnish my acrylic works as the polymer in the paint acts as protection in itself, and good-quality paints will contain a UV shield, but this is personal choice. Mixed-media work that is not going to be displayed behind glass, however, will require at least one varnish coat to protect all those beautiful, sometimes fragile, materials that form the creation of the final painting. I use either matt medium or gloss medium depending on the finish I require and apply maybe two or three coats with a wide brush. I prefer to brush these mediums onto the surface to make sure that they get into all the nooks and crannies formed by the texture and layers. The mediums dry transparent so there are no brush marks visible. There are many other varnishes on the market in both spray and liquid forms that you can use in gloss, matt or satin finishes – the choice is yours.

Once the varnish has been applied and thoroughly dry, it's time to decide how to display your work.

Unframed canvases

These require no more than D-rings or other hanging appliances and string or wire fixed to the back of the canvas. They stand proud on any wall. It's a personal choice on how to finish off the edges of a canvas. I tend to paint mine in black acrylic paint or gesso to hide any residual marks from the paint: some artists leave these paint marks on as part of the development of the painting and others take the design around the edges. It really is up to you.

Float frames and box frames

A canvas can be enclosed in a float frame or box frame to add a more professional look and add depth. A float frame will have a margin around it to show off any enhanced edges, whereas a box frame is usually mounted tight to the canvas obscuring any edges.

Works on paper

Works on paper are usually 'framed' by a single or double mount and then set behind glass which is then enclosed in a frame.

Adhering to wood panel

Works on paper can also be cropped and mounted onto a wood panel with strong glue. This will give the appearance of a canvas and needs no further mounting. However, if you use this technique, make sure that you have no vulnerable materials worked into the painting, such as pastel, water-soluble materials or charcoal and graphite, and give the piece at least a couple of coats of varnish for extra protection.

INDEX

accent(s) 8, 24–25, 26, 50, 53, 71, 73, 166–167, 174
assemblage 65, 100–101, 119, 166

background(s) 12–17, 24, 53, 63, 67, 71, 73, 74–99, 104, 107–109, 110, 121, 133, 163, 169
blocking in shape(s) 14, 31, 46, 53, 56–57

CitraSolv 70–71, 80–85, 103, 168–173
collage
 components 100–101
 different approaches to… 110–113
 ephemera 12–17, 100, 107
 fabric 118
 paper(s)
 creating your own… 102–106
 cutting and tearing 108
 decoupage papers 101, 168–173
 dressmakers' pattern 28–29, 80–85, 101, 120
 graffiti 106
 hand-decorated 90, 104, 132
 preparing and adhering 109
 stained tissue papers 87, 105
 staining papers 104
 text, words 10, 30–35, 50, 65, 73, 80–85, 87–93, 100, 104, 107, 111–117, 120, 133, 140, 158, 166
 textured 13
collograph prints 134, 142
colour(s)
 choice(s) 19, 21, 22, 28–35, 42, 73
 combination(s) 10, 20–21, 52, 164
 complementary 25, 26, 123, 164
 palette(s) 12–17, 19, 21, 24–25, 28–35, 49, 50, 104, 107
 primary(-ies) 20, 22, 25, 96
 scheme(s) 28, 31, 96, 164, 166
 monochromatic 30–35, 164
 wheel(s) 20–21
composition 12–17, 19, 20–21, 22, 24, 28–29, 36–41, 42–45, 47, 48–51, 52–53, 54–57, 61, 68, 73, 80–85, 89, 91, 106, 107, 143, 163, 164, 166–167, 169, 174
 principles 36–39, 42–45

compositional format(s) 12, 36–39, 42, 45, 49, 50, 61, 80, 166
contrast 15, 20, 26, 35, 42–43, 45, 53, 56, 82, 96, 115, 124, 163, 164, 166–167

deli paper 102, 104, 120, 132, 138
design
 elements 15, 19, 43, 50, 53, 110, 136, 160–161, 163, 166
 principles 42, 161–163
dry media 53, 63, 68–69, 123, 126, 148, 152, 155, 166–167
 art bars 56, 57, 68–69, 70, 122–123, 156
 Brusho 19, 30–35, 68–69, 70, 86, 87–93, 167
 brush pens 68, 70–71, 110
 charcoal 8, 12–17, 26–27, 28–29, 30–35, 40–41, 46–47, 53, 54–55, 68–69, 80–85, 87–93, 126, 156, 166, 167, 168–173, 175
 graphite 8, 68–69, 126, 175
 Inktense pencils 30–35, 55, 68–69, 156, 167, 168–173
 oil pastels 8, 9, 19, 28–29, 30–35, 42–45, 46–47, 50, 58, 61, 68–69, 73, 77, 80–85, 118, 122–125, 126, 148, 155, 166–167, 168–173
 pan pastels 68–69, 166
 pastel(s) 8, 20, 22, 40–41, 62, 65, 68–69, 71, 87–93, 122–125, 126, 166–167, 174–175

floral(s) 46–47, 86–93, 160, 164, 168–173
focal point 52–53, 57, 58–59, 61, 84, 90, 96, 98, 116, 158, 164–165, 166, 171
font(s), typeface(s) 10, 73, 111

gelli plate 71, 102, 105, 134, 138–141
glaze(s), glazing 42–45, 47, 57, 65, 67, 70–71, 80–85, 114–117, 130–133, 155

handwriting 10, 102, 150, 157
highlight(s), highlighting 50, 58, 90, 166, 169, 174

isopropyl alcohol 12–17, 30–35, 40–41, 66–67, 107, 126, 154

landscape(s) 28–29, 36, 49, 52, 57, 65, 78, 80–85, 86, 112
lifting paint 53, 126–127, 128–129

monoprinting 71, 102, 134, 143

negative space 12–17, 36, 89, 91, 122

observing the direction of the painting 15, 43, 52–53, 57–59, 117, 125
order of work 19, 53

reworking, transforming an old painting 10, 52, 128, 136, 158, 161

sanding 66–67, 114–117, 129
shaping 48, 54–55, 56, 69, 80, 107, 122, 169
spray starch 63, 66–67, 71, 86–93
squeegee(s) 42–45, 66–67, 74, 94–99, 104, 144
stamp(s), stamping 12–17, 40–41, 50, 61, 77, 80–85, 87–93, 95–99, 104, 106, 114–117, 127, 128, 134–135, 136, 138, 140, 151, 152, 153, 156–157, 158, 160, 161–163, 168–173, 168–173
stencil(s), stencilling 12–17, 50, 57–59, 61, 65, 69, 71, 73, 76, 77, 87–93, 95–99, 103, 104, 110, 126, 128, 134–135, 136–137, 139, 151, 152, 156, 160, 161–163, 165, 166, 168–173
substrate(s) 39, 53, 62–63, 65, 67, 71, 74–77, 81, 94, 95, 107, 109, 114–115, 118–119, 120, 129, 134, 144, 152–153, 156
support(s) 62–63, 74
symbols, symbolism 15, 148–149, 150–151, 157–159

texture plates 138–139
typeface(s), see also: font(s) 73, 111, 112

underlayer 53, 69, 127, 131
underpainting 8, 28, 52, 55, 61, 71, 107

varnishing 65, 103, 174–175
veiling 53, 65, 73, 83, 94, 120–129
viewfinder, viewing mat 42–45, 46–47, 57–59, 87–93, 106, 143

waste paint palette paper 94, 122–125
water-soluble media 57–59, 69, 70–71, 86–93, 122–125, 156, 166
wet media 67, 70–71, 73, 126, 148, 153, 154
 ink(s)
 acrylic 19, 40–41, 46–47, 50, 70–71, 80–85, 86, 87–93, 130–131
 Indian 12–17, 28–29, 30–35, 40–41, 42–45, 46–47, 57–59, 70–71, 95–99, 106, 114–117, 118, 129, 144–147, 155, 158
 liquid watercolour 28–29, 70–71, 87–93
 paint(s)
 acrylic 12–17, 28–29, 30–35, 40–41, 42–45, 46–47, 48, 49, 50, 57–59, 61, 65, 67, 70–71, 73, 79, 80–85, 86, 87–93, 95–99, 102, 104, 105, 110, 114–117, 118, 126, 130–131, 138, 142, 145, 149, 153, 155, 161–163, 168–173, 174
 fluid acrylic 42–45, 70–71, 86, 87–93, 130
 gouache 8, 56, 70–71, 73
 Open acrylic 70–71, 102, 142
 oil 8, 70–71
 spray paints 70–71, 104, 152, 156
working on a series 11, 41, 48–51, 78, 128, 161

Acknowledgements

To all the team at Search Press. To Mark Davison for his incredible photography and patience.
To my editor Beth Harwood for her painstaking reviews and commitment to my work and making this book possible.
To Claire Du Plessis, my studio buddy, for her innovative studio shots and for putting up with my chaotic and disorganized studio space during the making of this book.
To John Harding (chauffeur) for driving 'Miss Daisy' to and from photoshoots.
To Rosanna Parker for introducing me to creating and printing with collographs.
To Ivy Newport for her tireless encouragement, wonderful supportive art community, and for introducing me to many new techniques.
To Lora Murphy for giving me the chance to delve into encaustic painting along the Nile and in her wonderful encaustic studio in Ireland, Essence of Mulranny (EOM Studios).
To all the fantastic and talented artists I have had the pleasure of meeting on my many travels and for their fun, laughter and friendship.
Lastly, my thanks goes out to Roz Dace for giving me the chance to write this book and for believing in my work.

SEARCH PRESS LIMITED

50

The world's finest art and craft books

BOOKMARKED
The Creative Books Hub

from Search Press and David & Charles

WHY JOIN BOOKMARKED?

- Membership to world's leading art and craft book community
- Free projects, videos and downloads
- Exclusive offers, giveaways and competitions
- Share your makes with the crafting world
- Meet our amazing authors!

www.bookmarkedhub.com

For all our books and catalogues go to **www.searchpress.com**

www.searchpressusa.com www.searchpress.com.au

Please note that not all of our books are available in all markets

Follow us @searchpress on: facebook twitter pinterest instagram linkedin